Roger Cardinal teaches French and Comparative Literary Studies at the University of Kent. He is the author of *Surrealism: Permanent Revelation* (with Robert Short, 1970) and *German Romantics* (1975), and of an essay on the modern poetic imagination, *Figures of Reality* (1981). An authority on Art Brut (*Outsider Art* (1972)), he has written widely on marginal creativity, including naive painting (*Primitive Painters* (1978)). In addition he is a secret diarist and poet.

D1584827

ROGER CARDINAL

EXPRESSIONISM

SERIES EDITOR
JUSTIN WINTLE

PALADIN

Granada Publishing

Paladin Books
Granada Publishing Ltd
8 Grafton Street, London W1X 3LA

Published by Paladin Books 1984

ISBN 0-586-08434-7

Reproduced, printed and bound in Great Britain by
Hazell Watson & Viney Ltd, Aylesbury, Bucks

Set in Baskerville

CONTENTS

ACKNOWLEDGEMENT

The author thanks Dora Musi for her tender concern for the manuscript.

NOTE ON TRANSLATIONS

Wherever possible, I have transcribed German terms into an English equivalent in an effort to dispel any superficial strangeness about German Expressionist concerns. The term 'the Blue Rider' has achieved popularity; I therefore see no reason not to transcribe *Die Brücke* as 'the Bridge'.

All verse renderings are my own.

ILLUSTRATIONS

FOREWORD

It is a fundamental tenet of Expressionism that the true creative impulse springs from a source deep within the individual, at a primal level of emotional life untouched by knowledge of academic art, art history and indeed history at large. The desire to create is thus identified with a timeless urge which, in principle, can manifest itself at any time, in any culture and in any part of the world. Expressionism in this trans-historical sense is the most flexible of concepts.

It is worth noting that the German Expressionist painters of the 1910s and 1920s were themselves very keen on the idea of a 'universal expressionism'. Of the two major groups in German Expressionist painting, the Bridge group (*Die Brücke*) was enthusiastic about African and Oceanic tribal sculpture, medieval German woodcuts and children's drawings, finding in them an immediacy and a dynamism far superior to what were seen as the effete styles of contemporary European academic art. The other group, known as the Blue Rider (*Der blaue Reiter*), advertised the wide span of its aesthetic tastes when it issued an Almanac (*Der blaue Reiter*, 1912) containing nearly 150 illustrations. Of these, about one-fifth were of works by contemporary avant-garde artists working in Germany, and another fifth of recent work by artists in France, from van Gogh to Picasso. The remaining three-fifths of the illustrations covered an amazing range of alternative material, much of it little known and all of it very distant from the kind of art we associate with the European norm. The miscellany included folk art from Bavaria, Russia and South America; tribal art from Africa and the Oceanic regions, including an

1

Easter Island statuette and a blanket woven by Chilkat Indians; medieval German engravings and carvings; silhouette figures from Egyptian shadow plays; anonymous Japanese ink drawings; and pictures by children and amateurs, along with several works by the naïve artist Henri Rousseau (who was far from being a recognized master at the time). This exuberant profusion of examples went without verbal comment; the intention being, we may infer, to demonstrate through visual argument that the new painting in Germany considered its frame of reference as transcending all orthodox boundaries. These were works produced by people of many nations, from many different periods of history; many works were in media not recognized in academic art; many of the creators might not even be considered to be artists in the conventional sense. Where, then, lay the common denominator in this abundant diversity? Precisely in an omnipresent impulse of pure creativity, fostered by a 'primitive' sense of spontaneous form independent of European models.

It would be tempting, in a book of this kind, to argue for this, the most emancipatory definition of Expressionism. If what is under discussion is something that crops up in so many different locations, it could be great fun to dash from example to example – comparing a child's drawing to a Red Indian design, a rock-painting to a van Gogh – and so building up, bit by bit, a dazzling array of examples, all grouped under the Expressionist label. There are two reasons why I have chosen not to yield to this temptation. First, a trans-historical sweep cannot have much meaning unless accompanied by a full display of comparative illustrations. There are literally dozens of periods and movements which, at various times, have been dubbed 'expressionist' and an unprejudiced cataloguer would need to allow space for the Willendorf Venus, pre-historic cave-painting, Assyrian and Egyptian art, Romanesque carving, medieval popular woodcuts, Michelangelo, Grünewald, Bosch, El Greco, Goya, Blake, Turner, Monticelli,

Daumier, Rodin . . . to cite only a few from the list up to 1900. Clearly the format of this book cannot cater for such extravagance.

But my second reason for having backed off from the 'wide' definition of Expressionism is that, while it would have certainly encouraged intriguing speculations, such an inquiry seemed unlikely to lead to any decisive conclusion. Any inquiry into Expressionism which is so open-ended would either lead to a tautology – 'thus we conclude that all the works chosen to exemplify the universal principle of emotional expressivity *do* indeed reflect that principle'; or else, it would throw up an irreducible mountain of a definition, full of labyrinthine twists and undermined by a hundred doubtful cases.

On the other hand, the diametrically opposite approach also has its drawbacks. What is the most pedantic and austere definition of Expressionism?[1] Formulated in exclusive terms, it might well designate the activities of a select number of German artists, centring on the Bridge group (Kirchner, Pechstein, Nolde and others), and be strictly dated between 1905 (foundation of the Bridge) to 1925 (already rather a late date to mark the end of full-scale Expressionist activity). Caught within these puristic confines, the 'narrow' approach at once runs into difficulties. Should a study of this kind of Expressionism be limited to German painting, and thus ignore the contribution of artists from abroad, principally Paris (Matisse, Delaunay, the Fauvists)? Would Jawlensky (a Russian) and Kokoschka (an Austrian) qualify? Should the Blue Rider group be included, or excluded as being too spiritual, too sophisticated, to fit in with the provocative barbarians of the Bridge? What about Klee, whose airy improvisations seem light years away from, say, the earnest landscapes of Nolde, with their thick, damp colours? And what about the other arts, such as poetry and music?

Attempts have been made to reduce Expressionism to the small format. And, of course, one has to admit that a narrow definition, even where it ignores important figures,

does give the critic a chance to concentrate on a select number of problems and thus, if all goes well, to arrive at sharp critical insights (which may or may not prove suitable for later 'exportation' outside the restricted territory). The mass of secondary material available to us in the German language tends to dwell on the narrow end of the scale of definition, and has the merits and drawbacks of this concentrated approach.

Given that I am unhappy with these two extremes, how did I resolve the problem of scope in this book?

Let me begin by marking out the general territory of my concerns. It is almost mandatory for books about Expressionism to start proceedings with a lengthy 'roll-call' of participants in the movement. I must say I am doubtful about the value of such lists, because I don't see that any register of contributors to such a diverse movement as Expressionism can possibly be impartial and complete. There are far too many borderline cases which remain open to dispute – fascinating dispute, perhaps, but hardly appropriate to the modest scale of this book.[2]

None the less, and despite these reservations, I decided to risk a provisional checklist of the principal figures associated with Expressionism during the last hundred years or so. Within this period, I suggest six broad categories.

(i) *Late nineteenth-century European forerunners of Expressionism*

This category is devoted to individualists whose work anticipates Expressionism in significant ways, and includes some decisive intellectual influences, such as Nietzsche. As for van Gogh, Munch and Strindberg, popular usage has (commonsensically) linked them to the Expressionist movement proper, so that it now seems pernickety to call them 'Pre-Expressionists' rather than Expressionists pure and simple.

Artists: Vincent van Gogh, Edvard Munch, Paul Gauguin, James Ensor, Ferdinand Hodler, Auguste Rodin.

Writers: Friedrich Nietzsche, Arthur Schopenhauer,

Fyodor Dostoevsky, Arthur Rimbaud, Émile Verhaeren, Walt Whitman, Arno Holz, Knut Hamsun, August Strindberg, Gerhart Hauptmann, Frank Wedekind.

Composers: Gustav Mahler, Richard Strauss

Dancers: Loïe Fuller, Isadora Duncan.

(ii) *Pre-War German Expressionism 1905–16*

Using the term 'German' to denote activities within German-speaking territories (i.e., it also implies artists from Vienna and Prague), I have dated this period as beginning with the founding of the Bridge and ending midway through the First World War: by 1916, a significant number of young artists and poets had been killed, and a deeper solidarity ensued.

It may be noted that painting and poetry were dominant during this first wave of Expressionist activites.

Artists: Ernst Kirchner, Karl Schmidt-Rottluff, Erich Heckel, Otto Mueller, Max Pechstein, Emil Nolde, Vassily Kandinsky, Franz Marc, August Macke, Alexei von Jawlensky, Gabriele Münter, Wilhelm Morgner, Ernst Barlach, Käthe Kollwitz, Ludwig Meidner, Oskar Kokoschka, Egon Schiele, Alfred Kubin.

Writers: Georg Heym, Georg Trakl, Ernst Stadler, Jakob van Hoddis, Alfred Lichtenstein, August Stramm, Gottfried Benn, Ludwig Rubiner, Albert Ehrenstein, Walter Hasenclever, Theodor Däubler, Georg Kaiser, Reinhard Sorge, Carl Sternheim, Franz Werfel, Franz Kafka.

Composers: Arnold Schönberg, Anton von Webern, Alban Berg.

Dancers: Rudolf von Laban.

(iii) *Post-War German Expressionism, 1916–33*

The post-war momentum of German Expressionism carried it to an indeterminate point in the mid-1920s or early '30s. The cut-off date, according to taste, might be set at 1923 (end of major theatrical output), or 1925 (emergence of *Neue*

Sachlichkeit). I have chosen 1933, the date when the National Socialist Party came to power and speedily took steps to suppress *all* Expressionist activity in Germany.

It can be seen that in this period other media came to the fore, though painting and literature remain dominant (many of the figures named in the first category as having been active before 1916 would, of course, have gone on working well into this second period).

Artists: Lyonel Feininger.

Writers: Johannes R. Becher, Kurt Heynicke, Alfred Wolfenstein, Paul Zech, Iwan Goll, Carl Einstein, Mynona, Kasimir Edschmid, Alfred Döblin, Hans Henny Jahnn, Ernst Bloch, Paul Kornfeld, Ernst Toller, Fritz von Unruh, Hanns Johst.

Film-makers: Robert Wiene, Paul Wegener, Karl Heinz Martin, Friedrich Murnau, Arthur Robison, Fritz Lang, Paul Leni.

Dancers: Mary Wigman.

Architects: Walter Gropius, Bruno Taut, Erich Mendelsohn, Hans Poelzig, Hermann Finsterlin.

(iv) *European avant-garde contemporaries, 1900–20*

It seems useful to list the names of some outstanding foreign contemporaries whose work may be said to be relevant to an understanding of German Expressionism. Several of the painters did in fact exhibit in German galleries, and there are many affinities still to be traced. Orthodox nomenclature dissuades me from labelling any of these artists as Expressionists, though a case could be made that many were 'expressionistic'.

France: Pablo Picasso, Georges Braque, Juan Gris, Henri Matisse, Maurice de Vlaminck, Kees van Dongen, Georges Rouault, Robert Delaunay, Frank Kupka, Marc Chagall; Guillaume Apollinaire, Blaise Cendrars, Max Jacob, Jules Romains; Igor Stravinsky; Vaslav Nijinsky.

Belgium: Constant Permeke, Frits van den Berghe, Gustave de Smet.

Italy: Umberto Boccioni, Giacomo Balla, Gino Severini, Luigi Russolo, Carlo Carrà; Filippo Marinetti.

Switzerland: Hans Arp, Marcel Janco; Tristan Tzara, Hugo Ball.

Czechoslovakia: Emil Filla, Bohumil Kubista.

Russia: David Burljuk, Natalia Goncharova, Michael Larionov, Casimir Malevich; Vladimir Mayakovsky; Alexander Scriabin, Sergei Prokofiev.

(v) *International inter-war Expressionism, 1920–40*

While Expressionism eventually faltered in Germany during the inter-war years, its influence spread outwards. Here are the names most usefully cited in this connection, though I should emphasize that not all the following would have acknowledged an express allegiance to Expressionism.

Artists: Chaim Soutine, Lasar Segall, Henri Gaudier-Brzeska, Mario Sironi, Diego Rivera, José Orozco, David Siqueiros, Marcel Gromaire, Matthew Smith, David Bomberg, Graham Sutherland, Hans Hofmann.

Writers: Antonin Artaud, Pär Lagerkvist, Eugene O'Neill, Elmer Rice, Karel Capek.

Film-makers: Benjamin Christensen, Victor Sjöström, Mauritz Stiller, Carl Dreyer.

Architects: Michel de Klerk, P. V. J. Klint.

Dancers: Hanya Holm, Harald Kreutzberg.

(iv) *International post-war expressionistic currents 1940 to the present*

Here, I am thinking of activities in the arts which arose well after the death of German Expressionism proper, yet which – as in the case of the international COBRA group or the New York movement of Abstract Expressionism – may be sensibly quoted as 'inheriting' the Expressionist spirit. Within this category, I have also listed the names of a good many figures whose work could be situated only within the

most sweeping definition of Expressionism suggested in my opening paragraphs.

Artists: Willem de Kooning, Jackson Pollock, Antonio Saura, Henri Michaux, Pierre Soulages, Franz Kline, K. R. H. Sonderborg, Hans Hartung, Bram van Velde, Wols, Asger Jorn, Karel Appel, Pierre Alechinsky, Jean Fautrier, Jean Dubuffet, Francis Bacon, Alan Davie, Arnulf Rainer, Friedensreich Hundertwasser, Joseph Beuys, Edward Kienholz . . .

Writers: Wolfgang Borchert, Günter Grass, Paul Celan, Peter Weiss, Thomas Bernhard, Dylan Thomas, Samuel Beckett, Eugène Ionesco, Allen Ginsberg, Kenneth Patchen . . .

Film-makers: Ingmar Bergman, Orson Welles, Andrzej Wajda, Werner Herzog, Glauber Rocha, Arrabal . . .

Composers: Luciano Berio, Krzystof Penderecki . . .

The reader is welcome to join in the game, by adding to or subtracting from this last list. I considered including the abstract painters Mark Rothko and Mark Tobey, the stage director Jerzy Grotowski, the choreographer Maurice Béjart, the poet Sylvia Plath, the theorist of Situationism Raoul Vaneigem, even the culture-critic George Steiner and the pop singer Klaus Nomi – on the grounds that their work contains echoes of some essential Expressionist themes. I have no puritan objection to quoting such names, especially where they reflect the persistence, in today's impoverished context, of powerful creative impulses reminiscent of those identified by Expressionism some decades earlier. Technically, though, it is as well to call a halt to this list, since the over-zealous application even of the more cautious term 'expressionistic' can lead to a watering-down of critical categories.

What all of this means is that I do not want to rule out automatically a flexible approach to the definition of 'Expressionism'. The territory I recognize in this book is principally that covered by categories (ii) and (iii), that is to say, the mainstream of Expressionism in the German-speaking countries. I shall however make reference to

figures in the first category, recognizing that earlier works still being discovered by the young artists of Germany made a distinct and lively contribution to the movement. And, looking in the other direction, I shall make allusions to a small number of figures from the other categories (iv), (v) and (vi). Such references – often to loners like Soutine or Wols – are not always justifiable in terms of chronology or group allegiance. I hope however that they do not betray the spirit of the context, and that they may help to alleviate an otherwise dogmatically Germanic emphasis.

So far, I have tended to speak of Expressionism as being a movement in the visual arts. It is a logical way to start, since painting was certainly the medium where Expressionism first made its mark. But a book called *Expressionism* would be misnamed if it ignored what I take to be one of the most salient (if sometimes neglected) aspects of the movement – its palpable impact on practically every kind of artistic activity practised at the time. Expressionist impulses can be traced in all the following media: oil-painting, drawing, lithography, the woodcut; book and magazine illustration; architecture; literature, especially poetry, the novel, autobiography and the essay; drama and theatrical production; cinema; orchestral and chamber music; opera and dance. It can even be argued that there are Expressionist philosophers (e.g. Ernst Bloch), Expressionist art historians (e.g. Wilhelm Worringer), and works of criticism cast in an Expressionist mould (e.g. Max Picard's book *Expressionist Peasant Painting (Expressionistische Bauernmalerei*, 1918) or Kasimir Edschmid's boisterous *On Expressionism in Literature* (*Ueber den Expressionismus in der Literatur*, 1919). In the social sphere, there were Expressionist trends in the field of town planning and of education, especially in the visual arts. And so, if lesser categories like interior design and the applied arts are set aside, the only media, as far as I can see, in which Expressionism left no appreciable mark are sculpture, aside from the isolated example of Ernst Barlach, and photography.

To this emphasis on the striking breadth of Expressionist

activities must be added the related point that many
Expressionist artists were themselves involved in more than
one medium of expression. Few movements in the arts have
thrown up such versatility. The painter Vassily Kandinsky
wrote theoretical texts, poems and plays; the sculptor and
woodcut-designer Ernst Barlach wrote plays, a novel and
an autobiography; the painter Oskar Kokoschka wrote
three plays, a novel and an autobiography; Ludwig Meid-
ner made his mark as a painter-poet; Walter Hasenclever
was both poet and dramatist; the painter Lyonel Feininger
also composed fugues; and the composer Arnold Schönberg
painted pictures and wrote poems, plays, stories, essays and
pedagogical works; while, from the earlier period, Strind-
berg was dramatist, novelist and poet, as well as an
accomplished landscape-painter and amateur composer.
The multi-media approach is foregrounded in the Blue
Rider Almanac, where texts like August Macke's lyrical
essay 'Masks' ('Masken') are juxtaposed with pictorial
illustrations and even reproductions of musical scores by
Schönberg and his friends. Here is exemplified that urge to
synthesis which Expressionism inherited from the German
romantics of a century before, allied to a refreshing new
sense of combined energies.

It is my belief that a full definition of Expressionism must
acknowledge these diverse concerns. Naturally, the
multi-media approach has its problems. For instance, there
is an unalterable factor of difference between an Expres-
sionist painting and an Expressionist poem, which is in-
separable from the general critical issue of how meaning
can be said to be embodied in an idiom of colour and line,
as against an idiom of letters and sounds. But at the risk of
gross simplification, I have opted to skate over technical
differences in these areas as being less important than my
emphasis on the synthesizing spirit of the movement, with
its cheerful irreverence for the boundaries of standard
aesthetic classification. Once involved with painters who
speak of their work in musical terms or poets who invest so
heavily in colour symbolism, I saw my inevitable strategy

as being to treat Expressionism as a dynamic and non-compartmentalized whole.

Dynamic it certainly was, even to the point of releasing energies so feverishly as to create an initial impression of utter chaos. Expressionism is indeed nothing if not a prospection of borderline states and extreme positions, often involving frenzies of indecision and hyperbolic gestures directed simultaneously in contrary directions. At times, Expressionists seem to posit agony as a kind of ecstasy, ecstasy as a kind of agony. Exhilaration and depression, attraction and repulsion, delicacy and brutality, harmony and noisiness, are but some of the antitheses embodied in their arguments or their creative acts. Expressionists can be obsessed by citylife, and yet yearn for the countryside. They prize individuality as a supreme value, and yet can be markedly enthusiastic about collective action. They thrive on sensations, yet they seek out a supersensory dimension of experience.

This being so, a perfectly even account of their aspirations would be bound to be wrong. The Expressionist movement was too disjointed and too de-centred to be reducible to a focal, orderly formula. To write about it is therefore to find oneself, at any given moment, holding on to only one of its protean manifestations. If I assert that the Expressionist is typically an impetuous soul, then I can be accused of overlooking his contemplative side. If I say that he is a neurotic solipsist, then I shall have lost sight of his warm sense of community. Such momentary losses of contact with the totality are, I would suggest, the inevitable accompaniment of any close study of Expressionism. To fasten on any single aspect is always to risk betraying the whole. But how can one otherwise proceed, unless one writes an entirely theoretical text, outlawing all examples? All one can do is to hope that some sort of pattern will emerge from the cross-play of divergent perspectives.

Unity-within-diversity is, then, the principle which I hope to bring out in the following discussion. Interestingly, while the artists at the time seemed bent on proving their

differences, contemporary criticism sought to stress the single-mindedness of the movement. A concept which enjoyed a certain vogue in the Expressionist period was the notion, advanced by art historians like Alois Riegl and Worringer, and adapted by contemporary apologists of Expressionism like Hermann Bahr and Paul Fechter, that major trends in style are a function of psychological orientation on a national scale, and so constitute what is called 'the spirit of the age'. To speak of Expressionism as the reigning *Zeitgeist* of the 1910s and 1920s is a little vague, but, I suppose, a valid starting-point. The generalization should be given nuance by reference to the dimension of group activity. For Expressionism can also be approached as the history of the artistic groups founded at various points during this period: the Bridge (1905) and the Blue Rider (1911); the circle of poets styling itself the New Club (1909); the artistic collaborations centred on Herwarth Walden's magazine and gallery *Der Sturm* (1910) and Franz Pfemfert's magazine and publishing-house *Die Aktion* (1911); Schönberg's Society for the Private Performance of Music (1918); the alignment of left-wing artists called the November Group (1919); the group of architects known as the Glass Chain (1920); the Bauhaus, founded in 1919 as a kind of guild of artists and architects dedicated to cultural regeneration; and so on.

On the other hand, there were many independent artists who did not join groups and, in a short survey like this, it is impossible to do justice to all the shades of their varying sympathies. What I propose to do therefore is to try to bear in mind the simultaneous and contrary trends of *collective awareness* and *individual initiative*, so as to keep in touch, in however crude a way, with both the distant and the near-to, the general and the particular. In this fashion, I hope, on the one hand, to establish some general critical models of Expressionist attitudes, working towards a kind of archetypal formula, and establishing guidelines for the understanding of the consensus view. On the other, I shall be offering many individual examples in clarification of these models.

In so doing I hope to avoid any sense that Expressionism was 'only' *Zeitgeist*, an anonymous stereotype to which individuals had to conform. On the contrary, Expressionism was *also* a spontaneous combustion of individual talents. It is with these varied stresses in mind that I propose to start with a discussion of the single sensibility, before moving on, in subsequent chapters, to a realization of universal Expressionist themes.

E.—2

I

EXPRESSION AND EXPRESSIONISM

In the straightforward sense, expression is a human activity which goes on practically all the time. It is indeed almost unthinkable that a conscious human being should be incapable of gestures and utterances which communicate meanings to others.

Of course, at the lowest level of physiological process, it might seem fastidious to speak of 'expression'. Ordinarily, basic functions like breathing, blood circulation and digestion tend to be interpreted as mechanical and therefore expressionless events. It would be odd to speak of the 'expression' of somebody's pulse, or the 'expression' of somebody's twitching muscle – unless in the exaggerated sense that the first activity is an 'expression' of the fact that the person is alive, or, in the second case, that involuntary twitching is an 'expression' of the person's having over-strained his body. However, once we work our way up the scale of physical movements, we soon begin to construe gestures and utterances of an expressive kind. A lover's caress may appear instinctive; we none the less interpret it as an expression of affection. A baby's cry may be 'unintentional' and even arbitrary; its mother may well interpret it as an expression of hunger or anxiety. Because expression is something we value so highly, we tend to be constantly alert to it. Indeed, our society expects us to be aware that expressions may be on offer at any time. We tend to 'read' people's faces, so as to identify the 'expression' thereon; we respond quickly to the frown on someone's forehead or the beckoning of someone's finger.

Let us agree to use the generic word *gesture* to designate

15

those physical movements which embody expression, the word *posture* to denote the special case of an expressive though motionless stance, and the word *utterance* to denote the special case of expression which emanates from the movement of the vocal cords. Further, given that we think of an expression as, by definition, more than just a neutral physiological reflex, then what we see as being expressed is necessarily something invisible, an inner meaning. The beating of someone's pulse is involuntary and expressionless (I'd prefer to say that the pulse-beat is a neutral sign of life), whereas a sudden movement of an arm or a long-drawn groan are almost immediately recognized by other people as being meaningful acts in which some sort of feeling or inner state is being 'squeezed-out' (*ex-pressed*) into a form perceptible to others.

Not all expressive gestures are simple. A lot depends on the interpreter: a lover anxious about his beloved's feelings will scrutinize the latter's every movement in search of signs of inner states which seem far from neutral. A lot depends on context: yawning in bed tends to mean something different from yawning at the dinner-table. Further, there are degrees of intentionality which can complicate the issue. Let us take the case of the man who lets out an unseemly yawn under his hostess's nose. A charitable interpretation might be that his yawn is merely a physical reflex, i.e., it is a sign of tiredness. Another explanation might be that while the man may well be tired, he is also bored by the conversation around him, and has been unable to summon up enough energy to stifle his yawn. His hostess will certainly see the yawn as an expression of boredom, however involuntary. Finally, we might suppose that the man is capable of yawning deliberately: perhaps he feels the yawn coming, realizes that it might be adversely interpreted, decides he doesn't care one bit, and so lets out the yawn in a way which publicly advertises his feelings. His yawn thereby becomes an act of *intentional expression*. In the extreme, it can become an act of deliberate provocation, expression as wilful challenge: 'I think

16

your dinner-party is awful, and what are you going to do about it?'

This trivial example may serve to situate our thinking with regard to the kinds of aesthetic expression with which this book is concerned. My basic distinction between involuntary (and therefore neutral) expression and intentional (and often provocative) expression, along with the distinction between physical and emotional stimuli, can throw light on the way we assess artistic gestures and utterances which purport to be expressive *of* something or other. Let's move on, shifting the discussion now to a consideration of feelings more intense than idle boredom.

Let us suppose that a person feels a deep emotion – it could be delight in a landscape, pleasure in the company of an attractive person, disappointment in a thwarted ambition. There is perhaps the possibility that the person might elect to hide his feelings. It is after all possible that he or she would have reason to keep them a secret. Again, some feelings are so overwhelming that they numb the expressive faculties altogether, as happens when someone is physically and mentally immobilized by the shock of bad news (though even here, one could argue that a motionless posture can have expressive character). However, if we assume that the person does give full rein to his or her expressive faculties, then there may be two basic ways in which feeling will manifest itself. First, it may come out in a spontaneous and unsophisticated manner. A woman may simply throw up her arms and laugh; a man may bite his lip, turn his face and weep. If such acts are interpreted, it will probably be as expressions of 'obvious' feelings. We generally have no hesitation about concluding that a woman laughing and waving her arms is a woman who feels happy. We 'know' that a man who has tears on his cheek and whose gestures and posture are stiff and strained, is, by and large, a man overcome by sadness. The happiness or the sadness is being made directly known to us (assuming that we are not too inhibited to notice such things!) through the expressive media of gesture, posture and utterance. In

such cases, we might speak in Wordsworthian terms of a 'spontanous overflow' of emotion.

Now, such expression is, strictly speaking, less than aesthetic, even when it can be construed as being in some degree intentional. The woman who waves her arms excitedly may be expressing exhilaration, and yet not produce anything very articulate. The expression she is releasing is in effect an *exposure* of feelings, a disclosure of the raw state of her emotions. But we should not necessarily assume that her actions are being wilfully organized for others to notice. Perhaps she just feels happy, so she waves her arms. She may not care about being seen – but she is not insisting on it. A different situation will arise once she does.

Now let us suppose that the person experiencing an emotion tends in the second direction. If we identify 'exposure' with unsophisticated expression, simply the uncontrolled overflow of an excess of feeling, then we can posit a more deliberate, sophisticated process which is the intentional expression of an emotion which aims at being noticed by another person or persons. This wilful sort of expression might be termed *performance* – though I would want to exclude any pejorative connotations of 'showing off' and to use this word neutrally to designate that mode of expression which presupposes an audience. At this point, we can say that the person expressing himself in this second manner is expressing his feeling *for* other people to witness. The performance of an emotion is thus a *wilful* communication of an inner state.

An alternative way of tracing the same stages is to work through a sentence using the verb *to express*. A gesture or utterance cannot simply 'express' in the void – it must have an object: 'Vincent expressed his feeling'. This sentence means something like 'Vincent had a feeling and that feeling manifested itself through some gesture or utterance of his.' Such a sentence would be logically complete without mention of any witness to that manifestation. But in certain circumstances, the sentence may logically need to go on to make such mention. The 'performative' mode of expression

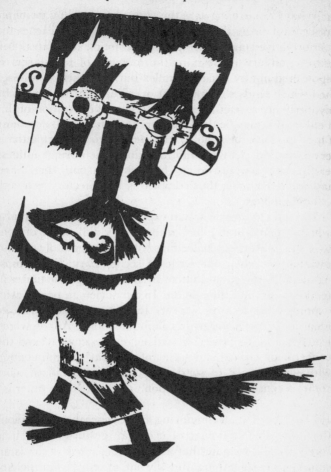

needs the adjunct of an indirect object before the sentence is completed. Our second sentence will then read: 'Vincent expressed his feeling to those around him.' This sentence means something like 'Vincent had a feeling, which was manifested through a gesture or utterance over which he exerted some degree of control, in such a way that his audience came to understand his feeling in a fairly precise way.'

19

What I am driving at is the notion of a guiding principle inseparable from the act of expression, when it reaches the performative stage. Once primary emotion translates itself into secondary expression, the moment of translation is sponsored not by muscular reflex but by an act of *consciousness* which lends shape to that overflow in order that it be properly interpreted by others. In acts of expression of this kind (and it may be that these are the ones which dominate our expressive behaviour) the element of performance is precisely that element of form-giving which brings fullness to the sentence, providing the verb with both direct and indirect object, and thus completing its trajectory as a verb of *communication*.

It could be said, then, that expression is a human impulse which remains unfulfilled without this dimension of contact. One *can* articulate feelings with no thought of communication, as when one writes a secret diary; but, almost irresistibly, the performative or form-giving function will tend to enter into the process. In our society, a person who expresses his feelings expects them to be noticed – he identifies expression with communication.[1] All of which leads us on to issues of artistic expression, where the concern for clarity and form, of efficient communication with an audience (desired if not always actualized), becomes a conscious preoccupation.

If I have been at all convincing in my generalizations about the expressive character of everyday gestures, then it is surely truistic to state that an organized work of art is an expression of something. But of what, exactly? In the field of commonplace gesture and utterance, we can expect the widest scope of possibility. A human being is capable of expressing all sorts of feelings during his or her life, and a random list can hardly be exhaustive: desires, fears, expectations, regrets, happiness and grief, preferences and dislikes, along with a whole gamut of intellectual concepts and of physical experiences. Artists can in principle address themselves to the expression of anything from this wide

20

range (with the proviso that they tend not to dwell on its more trivial elements). Broadly speaking, art deals with *feelings*, *thoughts* and *sensations*. A rough model of the functioning of the artistic process is that one of these emerges from within the artist in the performance, the form-giving expression of the artistic gesture, thus achieving its delineation in the work of art and producing a subsequent response in the audience.

It should be evident by now that a sentence such as 'this drawing is expressive' is a tautology. What we mean when we say such a thing is that the gestures embodied in the lines on the paper have a pronounced degree of expressivity, i.e., that they formulate something convincingly and completely, in a way which creates a strong impact. To make such a statement about a work of art is normally to imply praise: an 'expressive' artist is one who is fluent at handling the primary material of feeling, thought or sensation and rendering it in articulate, readily understood form.

I should like now to concentrate on the specific case of the expression of feeling. True, it can be argued that a work of art may in principle concern itself uniquely with conceptual propositions, and therefore express these in ways which an audience will absorb intellectually, without being in any way emotionally stimulated. Equally it can be argued that a work of art may in principle concern itself with communicating a sensation, or complex of sensations, in such a way that emotion forms no part of the expressive 'package'. I will not risk confusion by trying to quote actual works which might illustrate these two extremes: for I suspect that, in either case, some measure of emotional response in the audience will turn out to be an inescapable side-effect of the expressive act. I want simply to set aside these extremes as being of less central importance to this book, and to concentrate on works which are predominantly expressive of *feelings*.

We are now in a position to move on to the examination of the *expressionist* work of art. What I have been developing is a model of the work of art as a complex whole, formed in a

given medium (pictorial, verbal, etc.) and whose dominant characteristic is that it communicates a feeling, or a nexus of interlinked emotions. A work which I might spontaneously call 'expressive' thus looks to be a work which successfully transmits to me an ample supply of emotion. But if I go on to say that it is 'expressionist', then what I am saying is that it manifests its expressive capacity in an amplified way, with a premium placed on the impression of plenitude and depth. Van Gogh wrote: 'I want to make drawings that strike people, so that they will say of my work, "This man feels deeply".'[2]

A preliminary definition of the expressionist work is, then, that it is a work which makes the fact of expression dramatic and noticeable. It is a work in which the expressive function is so foregrounded that emotional resonances come across in exceptionally forceful ways.

I stated earlier that the expressionist impulse has been traced throughout the whole long history of the creative arts. If we are to define it in terms of foregrounded emotion, the term 'expressionist' can be readily applied to the widest range of works, from the leaping bison at Altamira to the frenetic drippings of Jackson Pollock, from the tortured limbs of Grünewald's *Crucifixion* to the ravaged face of Picasso's *Woman Weeping*.

Applied more incisively, the term can refer to the work of those artists or movements which initiate a rebellion against a stylistic orthodoxy which has lost track of the sources of spontaneous feeling. In this perspective, one might attribute an expressionist character to baroque art, seen as a flamboyant outburst of expressive forms designed to stimulate an agitation of the emotions, in reaction to the balanced decorousness of classical art. Again, the rebellion of European romanticism might equally be seen as a renewal of the expressionist principle, an emphatic re-assertion of the impulse towards emotional immediacy (as distinct from secondary elaboration or formal decoration). The modern movement of Expressionism which is the subject of this book may be seen as simply the most recent – though

certainly the most vehement – assertion of this principle of a return to the true sources of feeling, an alignment of creativity with the deep emotional and instinctual drives in man.

Modern Expressionism thus represents a peculiarly urgent version of the artist's perennial demand to be allowed to express himself without constraint. Its immediate antecedents are the irrationalist and instinctual declarations of a Nietzsche, the potent transcriptions of agitated inner life in the late pictures of van Gogh, the heightened scenic gestures of Strindberg. When Nietzsche makes the proud assertion that 'I have always written my works with my whole body and life, I do not know what is meant by intellectual problems',[3] he is offering, in its simplest form, an exemplary principle of Expressionism, the unhesitating reliance on the direct expression of feelings arising out of the creator's own life without the mediation and probable interference of rationality.

This is to emphasize a tendency in many Expressionists to disdain cerebral control. Emil Nolde writes that 'it's great when a painter can paint instinctively and with a certainty of intention, as he breathes or walks',[4] thereby suggesting an equivalence between expression and the most elementary physical movements, as if the expressive act could be a totally *unwilled* shaping of spontaneous impulses. The virtues of instinct and emotional directness emerge as central tenets in a host of such pronouncements. It is as though the Expressionist feels himself to be completely satisfied by the simplest model of the expressive process as outlined above. Van Gogh writes to his brother that 'emotions are sometimes so strong that one works without knowing that one works'.[5] Again this implies a minimum of conscious articulation, and a maximum of spontaneous overflow. It seems that the Expressionist visualizes the emotions as a self-justifying force, capable of modulating into expression without planning or reflection. Among the many statements of an Expressionist reliance on spontaneous facility, these words of Kandinsky's are typical.

I have never been able to bring myself to use a form which came to me by some logical way, which had not arisen purely within my own feelings. I was unable to invent forms, and the sight of such forms always disgusts me. All the forms I ever used came of their own accord; they presented themselves to me already shaped, and all I had to do was to copy them.[6]

This celebration of creativity as pure transcription of feeling, this notion that raw feeling, in a vital sense, is *already* articulate and formed, becomes one of the implicit cornerstones of the Expressionist aesthetics. It is in many ways a suspect notion, and many would see it as faulty and idealistic. But for the moment, I want simply to develop this outline of a fundamental faith in what is in effect the 'spontaneous overflow' model of expression.

This model is allied to the concomitant principle of *intensity*, another key element in the Expressionist credo. 'Intense emotions intensely expressed' might be the watchword for the Expressionist artist. While a simple view of expressionist art at large might be that it reflects an aesthetics of spontaneity whereby feeling simply spills over into unplanned forms, the general trend of modern Expressionism has been towards a deliberate accentuation of the affective character of the work, a wilful underlining of the expressive gesture. Rather than improvise in a happy-go-lucky manner and allow feelings to pour out casually, the Expressionist tends to drive his feelings into extreme forms, making emphatic play with his emotions in an audience-oriented performance. Further, once the Expressionist aim is seen as being to 'cram the largest possible content into the most acute and at the same time most simple form',[7] to quote Iwan Goll, expression is now being conceived as a process not merely of 'squeezing out' the emotion from its original container, the human soul, but a corresponding 'squeezing in' of the emotion into its new container, the work of art. This is one way of explaining the sense of exorbitant cramming exemplified in the minute drawings of a Wols or those 'miniatures' scored by Webern where a vast orchestra is asked to condense all its resources into a

performance lasting only a minute or so. Marks of the strain implicit in the process of direct transmission are often apparent and tend to constitute a veritable 'code of intensity' within the stylistic system of Expressionism. Let me cite one example of foregrounded straining. It is the last *Self-Portrait* of van Gogh (1890) in which the face, already marked by vehement strokes expressive of extreme spiritual tension, is backed by a ground made up of blue-green spirals and whorls which are, so to speak, the expressive imprint of a generalized intensity. The painting is the expression of van Gogh's emotional turbulence: and its style directly confirms that turbulence over every inch of the canvas.

Once the Expressionist elects to work out of his feelings, it seems almost inevitable that he should come to value *deep* feeling and *intense* expression. August Macke draws a telling analogy between the Expressionist painter and the wild animal on the hunt: 'Seeing his prey, the panther crouches, and as a result of seeing it, his strength grows. And the tension of his strength shows in the length of his leap. The form of art, its style, is a result of tension.'[8]

There can be nothing passive or facile about this creative posture. Though there may not be intellectual concentration, there is concentration none the less. It is the concentration of the instinctive faculty, the effort to coincide totally in all one's fibres with the emotion which is to be expressed. Like a panther crouching in anticipation of his leap, the Expressionist artist deliberately winds himself up for an act of expressive discharge: he seems to want to impel all his gestural potency into a single blow, to produce a mighty surging-forth of expressive energy which will translate the emotional nexus into a single outburst: the work as absolute expression.

A further implication of this commitment to expressive intensity is that the Expressionist work becomes not so much an act of communication, as in the normal case of the expressive work, but rather an act of imperious command. Once Edvard Munch has created an image of *Death in the*

Sick Chamber (1892), a scene full of distraught faces, droop-
ing postures, tangled bedclothes and a comfortless bare
floor, he has simultaneously introduced us to how it *feels* to
be in such a place of suffering and death; he is not just
copying a reality, but offering an emotional response to a
reality in which we are invited to participate. The message
of an Expressionist painting is so often one of bustling
injunction: 'thou shalt be stirred by this image!' Its whole
policy is urgency, immediacy, an appeal as direct as a hand
on the shoulder or a blow to the head. Its demand is that we
recognize its feverish proximity to source. Käthe Kollwitz
stated of her drawings: 'I have never produced anything
cold . . . but always to some extent with my blood.'⁹ Such a
claim seems to cry out for an adequate posture of response
from the person witnessing those drawings: they require to
be treated in ways which honour their vital force, their
passionate immediacy. The direct opening-up of feeling
demands to be openly received.

What I said earlier about the factor of performance in the
expressive act now comes into full relevance. For when an
Expressionist artist enacts the gesture of transmitting deep
and intense feelings into a deep and intense form, he will
surely not expect his effort to stop short at that stage. He
anticipates an audience. He expects that his gesture of
expression will carry across to become a communication to
someone else. A certain consciousness of *being watched* thus
informs the activity of the Expressionist, as he handles his
emotional resources. The factor of insistence which I have
mentioned derives precisely from this consciousness of other
people. Schönberg once stated his ideal in categorical
terms: 'A work of art can achieve no finer effect than when it
transmits to the beholder the emotions that raged in the
creator in such a way that they rage and storm in him.'¹⁰
Though it may be only an ideal, the Expressionist seems to
be asking that the artist's feelings be perfectly replicated
within the spectator's witnessing sensibility.

The perfect work of Expressionism has, then, the char-
acter not of a representation of feeling but of a direct

presentation of feeling. It does not come to us as a cool product, but as something still warm and active, full of breath and pulsations, like some living thing. And while there may be a place for an intellectual appraisal of the products of Expressionism, it remains the case that the primary mode of their appeal is non-intellectual. Aesthetic appreciation becomes a work of sympathetic adjustment in which the receiving sensibility settles itself in relation to the shapes of the expressive work. Sometimes there will be an appeal of a kinetic kind, as when a piece of music or a painting excites the nervous system by its aural or visual rhythms; more often, the response is emotional, an accession of the spectator to the affective vibrations within the work. Above all, the engagement which the Expressionist seems to posit is one of *participation* – the expressed emotion being re-animated within the receiving sensibility as an image might be projected on to a screen. Or, in another version of the same idea, one might imagine the receiver of the message dipping back into the feeling which was its precipitating cause. In this sense, the 'distinctive complex of vibrations' which Kandinsky sees as the creation of the expressive act is an entity *in motion towards* its sympathetic recipient, within whose sensibility the act will find its fullest echo.

If this line is pursued, it will follow that the aesthetic experience, so far as Expressionism goes, is indissociably bound up not only with questions of exposure and vulnerability on the part of the creator, but equally on the part of his audience. An Expressionist work is intended not as a persuasion or an allurement, but as a direct challenge to the reader's sense of being in the world and hence of being alive to the presence of other persons and their feelings. Let us look at this premise in relation to what might be seen as the natural medium for Expressionism, dance.

The direct embodiment of spontaneous impulses was indeed the aim of the dancer Isadora Duncan, who pioneered what amounts to a Pre-Expressionist style in Berlin in the early years of this century. Deliberately

renouncing the decadent trappings of the established ballet, with its painted-doll ballerinas twirling mechanically in sparkling costumes, Duncan would dart on stage in a simple tunic beneath which her bare body could be readily glimpsed, to execute a sequence of movements that developed spontaneously in response to unplanned inner impulses derived from her spiritual and emotional resources. The Expressionist dancer Mary Wigman took further this mode of gestural or expressive dancing whereby the motor actions of muscle, sinew and bone, sweeping and spinning within a performing arena, formulate in the most direct way the invisible motions of the dancer's spirit. While Duncan relied on musical accompaniment, Wigman used to dance to the beat of a few drums, or even dispensed with music altogether. In this way, she sought to create physical configurations which would be a literal presentation of her inner life. The emotionally intensified space defined by her bodily motions thus took on the character of a lens through which her spiritual reality was exposed. Escaping from the codes of choreography by insisting on a large measure of improvisation, Wigman offered her body as a direct signal of her personal intensity and urgent human presence. The aesthetic performance thus comes across in terms indistinguishable from existence itself, as Wigman pursues her desire to 'become one with these dances, to disappear in them, to live them'.[11]

While not all Expressionist art forms are so literally tied to the body, there is a pronounced tendency within Expressionism to stress the physical dimension of the creative process. This is certainly the case in oil-painting, where the painter's brush-stroke may be said to emerge out of an intimate correlation of spiritual impulse and physical gesture, a kind of expressive dance of the wrist and arm. The agitated character of most Expressionist canvases bears testimony to the tacit conception of the highly charged picture surface as being equivalent to the highly charged space through which the dancer whirls. The thick impasto of Nolde, who often dipped his fingers in the paint, scraped

it with bits of card or wood, and generally impelled an impression of bodily presence into the pigment; the vehement jagged strokes of Schmidt-Rottluff; the slashing jabs of Kokoschka, using blots of thick paint applied with palette knife or thick brush – these are as much imprints of bodies as the traces of imaginations. The textured surface of an Expressionist painting constitutes the explicit signature of a performance which, though long since completed in the literal sense, may still be recreated by the spectator who is prepared to lend himself to the activity of 'reading', or mentally re-enacting, the strokes of the painter's wrist.[12]

To crystallize these suggestions, I would now like to bring into play three categories of sign analysed by the semiotician Charles S. Peirce.[13] In his system, a sign can be (i) an *iconic* sign, one which has a clear-cut physical resemblance to that which it signifies, as a map of an island replicates the shape of that island; (ii) a *symbolic* sign, one whose relationship to what it signifies rests upon social convention, as when a written exclamation-mark signifies excitement, surprise or danger; or (iii) an *indexical* sign, one which signifies by virtue of an existential or substantial connection with its object, as when a footprint in the sand signals the recent passing of Man Friday, or a rash on someone's body points to the fact that he has caught scarlet fever. (These examples were proposed by Roman Jakobson.) Without entering upon discussion of the often complex interaction of such signs (it is claimed, for instance, that films draw upon all three types), I want at this stage to press the simple point that it is the last-named sign which best typifies the Expressionist communication.

Let me illustrate this contention by returning to the dance. When a classical ballerina raises her hands to her heart, her gesture is easily recognized as a sign in a code consecrated by centuries of tradition. The dancer's posture is, at that point, being used as part of a discourse which refers away from the physical particularity of the body in the direction of symbolic, i.e., non-literal meaning. This is the gesture as *symbolic* sign.

Now, if one imagines an Expressionist dancer raising her arms, one should not expect that movement to correspond to any pre-existing code, given that Expressionist dance deliberately rejects all tradition. The gesture must instead derive its meaning from the immediate situation, for that is where it has been generated. If the spontaneous motions of the dancer arise out of her inner being, it may be said that the raising of her arms is an *indexical* sign of her inner feelings – their physical equivalent, existentially related to what generates them. Moreover, since the gesture, practically speaking, is indissociable from the emotion, and there is no external code for us to refer to, we might do well not to attempt *any* verbal formulation of the 'meaning' of the gesture! Indeed, there is a view prevalent among Expressionists that there is something inadequate about verbal language. Maurice de Vlaminck once said: 'All my life I have tried to paint those feelings which cannot be translated into spoken or written words.' In terms of Peirce's distinction, an indexical sign cannot be transposed into a symbolic sign without losing its most vital properties. To quote Kafka: 'The inner world can only be experienced, not described'.[14]

If we agree to accept this notion of an existential or indexical bond between expressive sign (the work) and expressing agent (the artist), then we will, I believe, have a useful model for the ideal Expressionist work.

This is to speak for a whole-hearted investment of temperament and character into the act of expression. There should be no posing, no manipulation, no studied virtuosity. Like the pulse-rate which echoes the rhythms of a man's blood, like the footprint left by a live Man Friday sprinting on the sand, the Expressionist work tends to be offered to its beholder as the visible mark of a vital, intentional presence. It is no casual trace thrown off in idleness, but the imprint of a vulnerable human being, a distinctive and exposed presence. 'Form reflects the spirit of each artist. Form bears the imprint of *personality*', writes Kandinsky.[15] The direct transmission of emotional energies into the dancer's step or the painter's brush-stroke repre-

sents the unmediated expression of a phenomenological reality, and its immediacy places an imperative upon the receiver.

This is why Expressionism makes such a violent appeal to its audience, in a way which may seem aberrant within the traditions of modern European art, where the trends of naturalism and realism (the iconic tendencies, where reference is to the world of perceptions) tend to be counterbalanced by those of symbolism and constructivism (the symbolic tendencies, where reference is to conventional codes of meaning). Expressionism, for its part, asks its audience to attend to its products without thought of any outside frame of reference. Thus, if I look at a painting by Soutine, I might indeed be tempted to think of its iconic resemblance to a real place; or again, I might be tempted to consider the symbolic resonances of the motif; but I am above all impelled to face up to its quasi-visceral challenge and to feel its impact as the indexical registering of an intense temperament.[16]

Within the field of Expressionist poetry, a similar straining towards indexical immediacy may be discerned. Understandably enough, there is a basic sense in which all linguistic utterance, associated as it is with language as a socially defined system or conventional code, qualifies as the symbolic mode *par excellence*. (The whole thrust of post-Saussurean linguistics has been to confirm this notion of the linguistic sign having a purely arbitrary, i.e., convention-based relation to its referent.) Since poems need words, the Expressionist poet must inevitably operate in relation to the conventions governing the German language, and to this extent, produce *symbolic* signs whose meaning is codified and hence available at the level of intellect. However, impatience and emotional impetuosity do impel the Expressionist in the direction of an idiom which has an indexical, existential link to the feeling subject. Language of this kind tends to want to shake free of the constraints of grammar and orthodox vocabulary. It can then become a stammering, an agitated outburst, a breathless raving. In

31

one extreme form, the poetry of August Stramm, it takes leave of convention to the point of distorting syntax, forcing nouns to become verbs or verbs to become nouns. The eerie, splintered effect of these lines from the poem 'Battle' ('Schlacht') may be seen as a direct 'indexical' registering of Stramm's inchoate horror at the idea of trench warfare.

> Groaning grapples
> and
> stamps in the earth
> Seizing throttles
> and
> belches gnaws and props
> Breezes stop still
> and cling in spasms ripped
> Hacking dins
> and
> tinkles shrill to the ground
> hope shivers and gapes
> presentiment bleeds
> shrieking sprouts upwards[17]

In its ultimate reaches, the Expressionist poem may be said to aspire not to the condition of music, but to the condition of that most vehement of utterances, the scream.

I must concede that there are some dangers in this reading of the Expressionist message. I am aware of the pitfalls that can arise once one begins to suppose that tradition, precedent, convention, context and so forth can be discarded. The indexical sign has power and urgency only to the degree that we, as receivers of that sign, are prepared to re-enact its impulses, and so create for ourselves a sense of involvement in the original intimacy. It is not always easy to project oneself into a work in this way: a poem which one reads silently is particularly difficult to draw into one's own sensibility on indexical terms. (Ideally, one would like to have heard the celebrated readings of Expressionist poems by the actor Richard Blümner in the pre-1914 cafés of Berlin; presumably his utterances and gestures restored an indexical dimension to the poetic word.) Moreover, I am

wary lest my invitation to consider the imprint of artistic temperament in the texture of the work should become an invitation to plunge the work into a pool of sentiment or sensational associations of a biographical kind. The problem is that, whether or not they wished it (and some might argue that the Expressionist emphasis on performance rather than product is to blame), many major Expressionist names have become surrounded with a legendary aura of the excessive. Wasn't Soutine the painter who hung a whole side of beef in his studio to do a still-life, and who, despite the ensuing stench, kept at work for weeks, throwing buckets of fresh blood on the carcass to sustain its colour? Didn't Trakl write his last poem at the Galician front-line and commit suicide by a cocaine overdose after a horrific night tending badly-wounded soldiers with no medical supplies? Wasn't Strindberg the man who would stand naked by an open window at night to measure the static electricity in his body and who wrote an *Occult Diary* about his hallucinatory erotic encounters with a mistress living miles away? The widespread popularity of van Gogh's paintings may have as much to do with the story of his severed ear as with the actual message of his work. Where emotionalism is the substantial experience of works of art, it can be that, as observers, we give way to the wrong sort of emotion, placing too crude an emphasis on the existential factor. Admittedly, we are bound to want to find out something about van Gogh's life once we have encountered his works; yet to place biographical knowledge in the forefront of our responses is to miss the point, and indeed to dispel the genuine immediacy of their effect. What is vital is not to know what psychological crises van Gogh went through, but to witness his paintings as expressive statements of inner crises which *we* encounter undefined. What we then make contact with – in the most powerful way – is not a raw slice of macabre biography, but the vibrations of a concentrated sensibility, a temperament re-animated within our own responses.

It is in this sense that I would define the Expressionist

intent: it is to stretch the powers of expressivity to the limit by acts of transmission so potent as to annul critical distance. The Expressionist sign beckons the viewer into the most direct contact with the initiating feeling, so that he coincides with it – if only for the space of a moment of imaginative fantasy – himself the 'performer' of that expression, the one who feels *now* what was felt *then*. Impulse, expression and interpretation cohere in a single, shared pulsation.

II

THE EXPRESSIONIST PROJECT

Passionate and urgent, the creative impulse in Expressionist art springs from a commitment to the primacy of individual truth, to subjectivity as verifier of what is most real. This commitment is a central tenet of a current of philosophical and psychological thought which, springing from German romanticism and relayed by such individualist thinkers as Stirner and Nietzsche, was emphatically revived in the Expressionist period.

The starting-point for the Expressionist is an irreducible sense of his own being. Possessed by the insistent claims of his impulses, he begins to formulate expressions of private emotion which will tend to consolidate the ascendancy of the one who feels. Art thus functions to sustain the conception of the priority of the subject. In many cases, however, the discovery of one's self as a unique and independent case is experienced in ways which are not comfortable. The relationship of an intensely emotional and self-preoccupied person to the world around him is often a troubled one. A sensitive subject is exposed to life, presenting himself as vulnerable to the harsh impact of contingent events. So the Expressionist, coiled around his central core of feeling, may turn towards outer reality with a sense of trepidation, yet still value the exposed posture of standing at the uncertain boundary between self and non-self. Kafka's story 'The Burrow' ('Der Bau') is an allegorical presentation of just this predicament. An unidentified animal speaks an obsessional monologue about its attempts to dig an impregnable burrow which will protect it from invisible aggressors, and yet which on occasion assumes the appearance of a trap.

The burrow can be taken as a symbol of the indulgent self-justifications of the unique consciousness; it is on the other hand an enclosed, stifling space upon which outer hazards impinge with fearful unpredictability. To exist as a person, Kafka is suggesting, is to confront this acute sense of difference between self and non-self, between the realm of fantasy and the terroristic circumstances of materiality. In a letter describing his insomnia, Kafka writes: 'What vulnerable or even precarious ground I live on, over darkness from which the dark power emerges whenever it likes and, without heeding my stammering, destroys my life.'[1]

The precariousness of Being is a thematic constant in a whole range of Expressionist writings, prefiguring subsequent developments in the literature of Existentialism. A poem by Franz Werfel provides a good example. Its title, 'Out of my depths' ('Aus meiner Tiefe'), situates the theme of metaphysical disquiet in terms of a *de profundis* entirely accented towards the subject.

> From my depths I cried out to you.
> I cried out as though stepping up from engulfing
> fevers: Where am I?
> Reeling crazily, I stood in a swerving landscape, amid
> the giddiness of secret earthquakes, and cried out:
> Where am I?
> I recognized the world. It was hanging by one last
> twitching nerve.
> I saw the deathly sweat on things as they threshed
> about in spasms of agony.[2]

Disorientation is absolute. The subject can establish no foothold in a space which shifts and writhes about him. He is lost in an estranged and dying world in which there is nothing to answer his cry.

The notion that the alienated subject is trapped in an intolerably uncertain universe represents one extreme of the Expressionist conception of man. It attains its most forceful expression in that notorious *scream* which, arguably, condenses into a single, utterly emphatic utterance the full weight of Expressionist emotion. Munch's painting of this

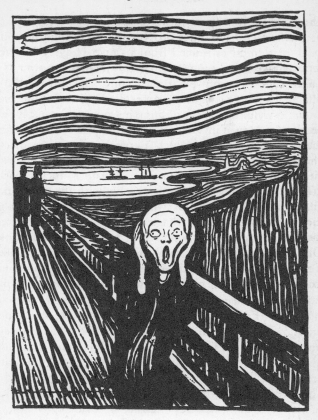

title is one of the key images of Expressionist art. It depicts a skeletal figure on a jetty set against a background of dynamic, swirling lines that delineate a space of empty water and remote mountains. Despite one or two people distantly promenading on the jetty, the figure stands alone. It (one cannot identify the figure as either male or female, so starkly does it signal the unqualified meaning of loneliness) stands with hands to either cheek, the gaping mouth held wide in a shriek which seems to resound across the surrounding emptiness. What is the message of the scream? It could be the expression of a metaphysical anguish at

being severed from the natural world, of the social torture of being alienated from other people, or even of the psychotic frenzy of a mind estranged from its own body. Whatever statement we apply as a caption to this image, its power as a non-verbal expression of extreme feeling is incontrovertible.

Munch's image constitutes an exemplary performance of the subjectivity in the act of 'pressing out' an intensely felt inner state. Almost incidentally, it makes use of a secondary mode of expression to which Expressionists often direct their attention: the articulation of invisible impulses by way of external forms, especially landscapes. In Munch's work, external settings are often co-extensive with the emotional lives of the human figures which inhabit them. Thus in *Virginia Creeper* (1898), a haggard-faced man with a red moustache stands as if transfixed in front of a house whose walls are covered by a ghastly scarlet growth of ivy, like some creeping stain which signals his pain and imminent collapse. The same principle operates in such Expressionist films as *The Cabinet of Dr Caligari* (*Das Kabinett des Dr Caligari*, 1919) or *Raskolnikov* (1923), where the inner condition of the central character is reflected in deliberately 'emotionalized' studio sets. The poets Heym and Trakl are specialists in the evocation of landscapes that are incarnations of psychic states. Trakl above all developed a distinctive type of frozen scenery as an external correlative for his secret anxieties. Its intensity is curiously enhanced by the studied quality of the performance, in which terse sentences and impersonal statements build up an effect of harrowing alienation. Here is a short sample of Trakl's topography of psychic exposure, from a poem called 'Psalm':

> There is a light, blown out by the wind.
> There is a moorland tavern from which a drunkard
> departs in the afternoon.
> There is a vineyard, burnt and black with holes full of
> spiders.
> There is a room, whitewashed with milk.
> The madman has died.[3]

Detail by detail, Trakl accumulates data which correspond not so much to a place or a situation as to a spiritual atmosphere or emotional complex. Isolated objects, minimally described, are cited as barren constituents of the landscape. Nothing is shown that is welcoming, fertile or life-enhancing. On the contrary: each line is a variation on a single theme, which might be summarized as 'There is nothing to be seen but dereliction and death'. And the flat, unexcited delivery of the sentences creates in the reader an emotional vibration which is almost a literal shudder: this is a discourse about emptiness and decay and its very language seems to shrivel into something deathlike.

Trakl is an extreme case of a tendency towards an estranged, negative view of reality. His subjectivism is none the less representative of the Expressionist approach to the world, revealing a crisis of the self which is a common starting-point in the Expressionist problematic of sensibility. Where am I? Which are my points of reference? If I can place no trust in appearances, how can I maintain my being against the menaces of external reality? How can I at all assert my sovereignty?

One reaction is to internalize all feeling, to seek release from the tensions of a hyperactive sensibility by way of acts of expression which spurn an audience. A quasi-autistic form of art is characteristic of such introspectives as Trakl, Kafka or Wols. What Kafka calls the 'tension between the subjective world of the ego and the objective world outside'[4] may be best controlled by a denial of the dimension of communication. Kafka was decidedly loath to release his texts for publication, and even instructed his friend Max Brod to destroy all manuscripts left after his death. Imprisoned in a concentration camp in wartime France, Wols improvised dozens of aphoristic texts and spiky drawings on scraps of paper, expressing his secret impulses to himself while keeping that expression more or less hidden from others.

Yet the expressive impulse is not one which can properly flourish in a confined space. Expressionism is, as I have emphasized, a bursting-forth of psychic energy, therefore an emission of gestures which will tend to leave traces on the outer world. To set marks on paper or canvas, to move limbs across space, is to initiate a performance which sooner or later presses out from the closed arena of subjectivity to lay claim to the attentions of an audience.

A useful pointer to this secondary stage of the Expressionist stance might be the practice of producing plays in which the artist's consciousness is projected on stage almost wholesale. Strindberg's motivation as a writer seems to be grounded in his unassailable confidence in the idea that his life is, if not comfortable, then certainly *interesting*: the

unabashedly autobiographical cast of his novels and plays makes of them so many projective analyses of aspects of his inner being. The characters he invents are not so much echoes of people he has encountered as stylizations of aspects of his own complex sensibility, so many fragments of himself. The truly Expressionist phase of his late work is exemplified by *A Dream Play* (*Ett Drömspel*, 1902) where the fact that individual persons are seen to step on stage is offset by the shifting indistinctness of the set and the de-personalized cast-list. Announcing a common practice in the Expressionist period proper, Strindberg designates one or two characters by their first name, but refers to the others generically as 'The Officer', 'The Father', 'The Gatekeeper', 'The Poet', and so forth. Separate persons subsequently turn out to be the same person, differentness simply merging into identity, in keeping with the writer's conception of 'characterless characters' who are figments of an overall consciousness. 'Characters divide, double, redouble, evaporate, condense, float out of each other, converge. But there is a consciousness transcending all – the consciousness of the dreamer', Strindberg asserts.[5] The play at large thus offers itself as an interior reverie within which token characters act out the fluctuating impulses and tensions of a single psyche. The creative sensibility is thus 'performing itself', exposing itself to the gaze of others.

Strindberg wrote *A Dream Play* scarcely a year after the publication of Freud's *The Interpretation of Dreams* (*Die Traumdeutung*), and it is surely no accident that the development of Freud's analytical method of exposing the hitherto invisible territory of the human psyche should have coincided with a general trend in the arts towards the revelation of intimacies and neuroses which the previous century had had no way of describing. To take a flagrant example of an Expressionist working in or close to Freud's Vienna, Egon Schiele, one might point to the unsettling aura of acutely disclosed feeling, centred on a frenzied sexuality, which is the general impression made by that young artist's drawings and paintings. The emaciated torsos and twisted limbs

of some of Schiele's nudes suggest a concern to uncover libidinous urges, but above all to designate the body as the expressive locus of suffering. Images with anonymous titles like *Female Nude from the Rear* or *Woman with Raised Left Leg* (whether or not we can recognize Schiele's mistress in the red-headed figure), and abrasive self-portraits such as *The Self-Seer* (1910), in which the artist exposes onanistic torment with devastating frankness, are occasions of acute immediacy, nakedness and impersonality catching the viewer off guard. Exposure here undoubtedly includes an element of the pornographic (sexuality thrust at the viewer in a harsh, provocative way); it is equally an exposure of the most raw feeling, genuinely plausible emotionality which draws strength from its anonymity.

Such examples as these begin to suggest that Expressionism saw the artist as having almost an exemplary vocation for suffering. First associated with figures like Nietzsche and van Gogh (the latter was dubbed 'pathologically emotional' by Paul Klee), there spread among Expressionist artists the more or less unspoken assumption that if art has to do with intense expression, it is vital that the artist exhibit his own vulnerability. Kandinsky refers to 'suffering, seeking, tormented souls with a deep fissure, caused by the collision of the spiritual with the material'.[6] First sketched by the writers of the Storm and Stress movement in the 1770s, this notion of a fatal gap between aspiration and actuality, between inner and outer reality, re-surfaces in German Expressionism as the most powerful of creative myths. It sometimes seems compulsory for the Expressionist to express himself in terms of malaise, neurosis, nihilism. By what means can I be sure of expressing my deepest feelings? By dredging up material from those inner gulfs where anxiety and undefined pain prompt such panicky notions as 'consciousness means alienation' or 'to live is to suffer'.

Out of this nexus of feelings and themes spring the more extreme phantasms of Expressionist art. A shocking reversal of values seems to operate at times, such that positive impulses find their outlet through the more intensified

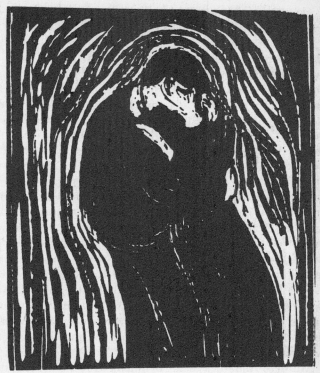

channel of negative expression. Thus the vital erotic drive can be re-routed in the direction of the gruesome and the fearful. Munch's many portrayals of woman tend to show her as a vampire intent on emasculating her sexual partner. The famous image of *The Kiss* (first version, 1892) may mimic the posture of sublime union, but its sickly and indistinct treatment can suggest (as it did to Strindberg, at least) an almost cannibalistic aggressivity. The bitterly nihilistic writer Gottfried Benn has one of his heroes refer to woman as a 'heap of secondary sexual characteristics, grouped in anthropoid fashion';[7] and in Fritz Lang's film *Metropolis* (1926), the healthy and life-affirming heroine Maria is supplanted, for a while at least, by a malefic look-alike robot who stands upon a gilded hydra and incites the

workers to a destructive rebellion that is tantamount to self-immolation.[8]

Fantasies of suicide may be seen as consistent with the Expressionist trend to engrossment with the self and its most intense feelings, of which anxiety and pain are inevitably the most acutely experienced ones. A morbid preoccupation with physical decay informs the poetry of Trakl, who was to kill himself in 1914. In several plays of Ernst Toller, including *Such is Life* (*Hoppla Wir Leben!* 1927), an idealistic young hero commits suicide in despair at the relentless negativity of existence. Toller was to take his own life in New York on the eve of the Second World War.[9]

Death is a commonplace theme in Expressionist reverie, cropping up in Georg Heym's anti-lyrical portrayal of the drowned Ophelia, 'a litter of infant water-rats nesting in her hair',[10] or the macabre depictions of dissected cadavers in Benn's morgue poems; or again in the many deathbed scenes in the pictures of Munch and Kollwitz; or in Fritz Lang's sombre film *Der müde Tod* (1921; literally, 'Death tired out', rendered unsatisfyingly as *Destiny* in the English print), where the chilling figure of Death is incarnated in a series of four guises, toying with and eventually seizing a young girl for his own.

Murder is the stock theme of much Expressionist cinema, whether occurring in the fantastical settings of Robert Wiene's *The Cabinet of Dr Caligari* or Friedrich Murnau's *Nosferatu* (1922), where innocents fall victim to a predatory sleepwalker or a vampire, or in the more psychologically plausible context of Wiene's *Raskolnikov* or Lang's *M* (1931). An Expressionist fixation on the specifically urban horror of the story of Jack the Ripper can be seen in its use as an episode in Paul Leni's *Waxworks* (*Das Wachsfigurenkabinett*, 1924) as well as the climax to Frank Wedekind's play *Pandora's Box* (*Die Büchse der Pandora*, 1902) (filmed by Georg Pabst under that title in 1928, and incorporated into Alban Berg's opera *Lulu* in 1937). Sexual violence is also the overt stimulus for one of the first successes of German Expressionist drama, Oskar Kokoschka's *Murder, the Hope of Women*

(*Mörder, Hoffnung der Frauen*, 1907), a sadistic fantasy in which ritualized sexual encounters culminate in a nameless Man throttling a nameless Woman and then running riot by killing all her female companions 'like flies'. Schönberg's atonal monodrama *Expectancy* (*Erwartung*, 1909) presents the interior monologue of a woman who dreams she may have murdered her lover; a sequence of jagged musical motifs which lack key signature and confirming structure, plus a vocal line scored to suggest a voice no longer entirely human, make of this work a harrowing nightmare, fundamentally discomforting in its refusal of thematic and formal securities.

Such attention to violence is symptomatic of the strain of nihilism in Expressionist thought, and may be attributed to a range of influences current during the shaping period of the movement. A full account of these cannot be given here, but the intellectual history of this strain would need to include an assessment of the impact of such cultural events as Nietzsche's shattering announcement of the death of God and the consequent vision of man's ethical landscape being stripped of all signposts; the potent watchword of *relativity*, derived from physics theory (Mach, Einstein) but now applied to the psychological and moral sphere to suggest the annihilation of all absolutes; sceptical and irrationalist currents of thought released by philosophers like Schopenhauer; the seductive correlation of artistic expression with mental derangement, as advanced in Cesare Lombroso's study *Genius and Madness* (*Genio e follia*, 1882); the collapse of an integrated model of the individual psyche initiated by psychoanalysis; not to mention the emergence of an aesthetics of shock derived from French decadence (Baudelaire, Rimbaud and their successors).

But the blunt fact is that the Expressionist sensibility was most deeply affected by events in the social and political sphere, and specifically the catastrophic circumstances leading up to the First World War. That so many works of Expressionism dating from the half-decade prior to the actual outbreak of hostilities in 1914 should speak in terms

of cataclysm and holocaust may lend some credence to Kandinsky's model of the Expressionist as a man of strong feelings who is like a 'well-played violin which at every touch of the bow vibrates in every part and fibre'" – as though the Expressionist soul were intimately attuned to the slightest vibrations of impending disaster passing across the European continent.

A celebrated early formulation of the theme of apocalypse is Jakob van Hoddis's poem 'End of the World' ('Weltende', 1911) with its deadpan undercutting of the solemnity of its title.

> The good citizen's hat flies off his pointed head.
> There's a sound like shrieking in all the winds.
> Roofmenders plummet down and burst apart.
> And along the coasts – so the papers say – the
> floodwaters are rising.
>
> The storm is upon us, the wild seas skip
> To shore, smashing sturdy dykes.
> Most people have caught a cold.
> Railway trains tumble off the bridges.[12]

Another poem of the same year is Alfred Lichtenstein's 'The Twilight' (*'Die Dämmerung'* – an echo of Nietzsche's gloomy formula of the 'Twilight of the Gods', which had gained popular currency), in which occur even more absurdly disproportionate images of disaster.

> A blond poet is maybe going mad.
> A little horse stumbles over a fine lady.
> A chubby man is glued to a window.[13]

The toytown absurdity of these events is suggestive of a tongue-in-cheek approach, the theme of apocalypse still not being faced as immediacy. None the less, the theme had been sketched, and progressively more strident and earnest prophecies of doom would follow. Of these, perhaps the most emphatic is Georg Heym's poem 'War' ('Der Krieg'), designed to be read aloud in emphatic style, as indeed its author did on a famous occasion at the Café Austria in

Berlin, a few weeks before his accidental (?) death by drowning in January 1912. The poem opens with a low-key sense of foreboding as the God of War stirs from his long sleep, and then builds to a horrific crescendo of full-scale destruction. I quote the second and then the final two verses:

> In the noisy evening of the towns falls
> Like frost the long shadow of a strange darkness.
> And the giddy whirling of the markets freezes fast.
> Silence reigns. People look over their shoulders. And
> nobody knows.
>
> A mighty town went down amid yellow smoke,
> Hurtling soundlessly into the belly of the abyss.
> But He stands gigantic over glowing debris
> And waves his torch thrice at the wild heavens,
>
> Over the reflection of tempest-torn clouds
> Into the cold wilderness of dead darkness,
> To wither up the night with fire far and wide,
> While sulphur and flame rain down upon
> Gomorrah.[14]

In 1912, Ludwig Meidner began producing a spate of writings and paintings characterized by an obsessive, almost ecstatic treatment of the theme of cataclysm. His *Apocalyptic Landscape* (1913) is a picture of an alpine town caught in a mighty explosion, its buildings and streets rearing up and shattering in a paroxysm of cruel forces. One or two of the last canvases of Franz Marc – ordinarily a painter of rare tranquillity and poise – reflect with an almost seismographic sensibility the tremors of inescapable catastrophe. Thus *Tyrol* (begun in 1913, though only completed in the following year during Marc's leave from the front-line, where he was to die two years after) sets the typically peaceful theme of animal life in an alpine environment horribly transfigured by a mesh of lightning-flashes, suggestive of the entire landscape being blown up.

As an experience of extreme horror, the war undoubtedly gave the Expressionists plenty to scream about; given the aesthetics of spontaneous feeling, it would not be unreason-

able to situate the Expressionist project in terms of a generation responding to an international phenomenon which transcended the individual sensibility. I am cautious about making too naïve a generalization about the war and its meaning for the Expressionists. There is some evidence that Franz Marc was not untypical in his initial enthusiasm for the fighting – motivated by a disgust for pre-war society and a consequent expectation of a fresh start once moral penance had been effected, plus a dash of irrational jingoism such as the Italian futurists had tied to their own programme of support for a violent renewal of social and artistic life. Marc was, arguably, equally typical of his generation in finding the brute facts of trench warfare totally at odds with his idealism, and in rejecting the war unequivocally once he knew what it was really like. By 1916, a pacifist stance had become the norm among the intelligentsia: the roll-call of Expressionists who had died at the front – including names like Lichtenstein, Stadler, Stramm, Trakl, Macke, Marc and Morgner – was an eloquent reminder of what war does to individuals.

In this sense, the meaning of the war for the Expressionist movement was that it forced the artist to shift from a model of the subject as a unique sufferer to one in which the subject suffers *in unison* with others. In this way, selfish metaphysical disquiet begins to modulate into angry concern about other people.

Once the war had thrown up issues on a larger scale than that of the isolated subject, it seems inevitable that the subsequent turmoil of the 1918 revolution and the agitated years of the Weimar Republic should have stimulated political awareness among the German Expressionists. But whereas the Italian futurists and the French surrealists were small, closely-knit groups which could work out a collective political line, the Expressionists were too scattered, too numerous, too little agreed on even an aesthetic programme, to be able to conform to any ready-made political credo. All that one can discern in broad terms is a general affinity with left-wing ideals, individual allegiances

DieAktion

XIII. JAHR. HERAUSGEBER: FRANZ PFEMFERT HEFT 12

INHALT: F. M. Jansen: Aufruhr (Titelbl. tt-Holzschnitt) / Jean Paul Marat: Skizzen aus dem Leben eines Revolutionärs / Karl Schöttig: Brief an Fritz Brupbacher / KLEINER BRIEFKASTEN / Die AKTION der AAUE / An die Leser der AKTION

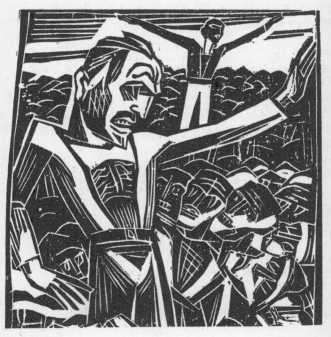

being spread among as many tendencies as existed on the Left: the communists, the social democrats, the spartakists, the anarchists, and so on. Reducing the interplay of political and artistic demands during these confused years to a few generalizations, let me simply say that: Expressionism *did* throw itself into the ferment of political debate, addressing its energies to a practical cause; it *did* draw up some elements of a programme appropriate to artists with left-

wing ideals; it *did* produce poets of some talent capable of producing acceptable writing with a political orientation. Thus the activist Ludwig Rubiner, author of the important essay 'The Poet gets his hands on Politics' ('Der Dichter greift in die Politik', 1912), formulates an eloquent appeal to international socialist solidarity in a poem called 'The Voice' ('Die Stimme'), where a chain of images alluding to rather than spelling out the facts of worker exploitation are heightened by a few deft touches of realism, including the mention of emblematic place-names from across the globe.

> A voice rose up soft as the thin cry of steam rising
> before the many-toned bubbles come to the boil,
> It leaped like sand in the wind into silent mouths, it
> slipped like a powerful flute-note over the stooped
> bones of tired labourers.
>
> Through steep black rooms swayed sun and moon;
> the stars zoomed through stinking wallpaper with
> ripped stains.
> If only the wondrous heavenly light would shine,
> before we all kick the bucket and rot!
> A voice flew and sucked its fill of filthy hours of
> workshop labour;
> Anger and hope circulate like blood, and hatred spits
> wet.
> A voice breathes blackly over poor quality paper from
> bankrupted printing-presses.
> A voice read out the whispered word: Strike! in the
> red shafts of the mines of Colorado.[15]

At the same time, it must be said that where political ideology was foregrounded there followed a predictable lowering of aesthetic tone. Thus Walter Hasenclever could write a poem entitled 'The Political Poet' ('Der politische Dichter') which reads like a clumsy attempt to conform to a popular political line. These verses project a self-serving image of the poet as the heroic militant who renounces the daydreams of a decadent symbolism in favour of direct contact with political reality.

> The poet dreams no more in azure lagoons.
> He sees bright multitudes ride forth from courtyards.

His foot covers over the corpses of the wicked.
His head is lifted high to accompany nations.

He will be their leader. He will announce the future.
The flame of his word will turn into music.
He will establish the great federation of states.
The rights of Mankind. The Republic.[16]

Such political gesturings suggest an idealistic, impractical frame of reference, rather than historical and political alertness, and it may be generally held that the influence of Expressionist poetry on the proletarian struggle was restricted.

In the sphere of the theatre, however, a different stress should be laid. Ernst Toller and Georg Kaiser were the most politically committed playwrights of Expressionism and they achieved considerable popular success with their work. Toller's anti-war play *Transfiguration* ('Die Wandlung' 1919) (composed in prison after his capture during the short-lived communist revolution in Munich in 1919) and his *Masses and Man* (*Masse Mensch*, 1921) present an impressive blend of angry political themes – the falsity of patriotism, the horror of war, the corrupt nature of capitalism, the necessity for revolutionary action – in an Expressionist style compounded of dreamlike scene-shifts between the real and the unreal, passionate rhetorical speeches, and a cast-list in which named persons are crowded out by anonymous figures who act as emblems of universal impulses rather than as people. Kaiser's programmatic dramas of social reality are equally marked by a strong social conscience, and manifest a glowing confidence in the possibility of human regeneration, of a successful revolution against the corrupt order of industrial capitalism. His major work, the *Gas* trilogy (*The Coral* [*Die Koralle*], 1917; *Gas I*, 1918; *Gas II*, 1920), emphasizes the theme of a new life opening up to those who can transcend the anonymous social functions – Worker, Secretary, Engineer, Gentleman, Billionaire – to which capitalist society reduces man. The high pitch of Kaiser's critique of so-called civilized values is reached in the climax to *Gas II*, where the excesses of

nationalistic mass passion lead to the detonation of a poison-gas bomb which brings about global destruction. Here is surely a demonstration that the Expressionist preoccupation with catastrophe is not, finally, the idle product of a perverse delectation for abnormal sensation, but an instinctive refusal of the warmongering mentality. And as a prophecy of the nuclear bomb, Kaiser's play retains its full potency.

Expressionism's critique of German society has overall consistency, whether it took as its immediate target the Wilhelmine regime which sponsored the disasters of war, or the post-war Republic fumbling its way into inflation and moral disintegration, and opening the way to Nazism. Here was a generation for which all the fundamental structures of social organization seemed to rest on negative principles. The acceleration of industry in the late nineteenth century, geared to the production of textiles and steel, and, in due course, rifles and dreadnoughts; the insistence on military and naval aggrandisement; the denial of worker initiative by a market economy profitable only to the rich; the erosion of individual liberties by big business, fronted by an oppressive bureaucracy; the assertion of mechanical calculation over feeling, quantity stifling quality – such were the broad themes of a general critique of everyday life which finds expression throughout Expressionist art. Carl Sternheim's *The Strongbox* (*Die Kassette*, 1912) centres on a money-box thought to contain a fortune bequeathed by an aunt to her nephew. The latter cynically spurns the needs of his wife and daughter in order to pursue the object of his passion, even though the box eventually turns out to contain nothing. The emptiness of a merely financial standard of values in life is the obvious moral of this satire. In Kaiser's play *From Morn till Midnight* (*Von Morgens bis Mitternachts*, 1916; directed on stage and then filmed by Karl Heinz Martin in 1920), the fetish of the banknote is further derided. An (anonymous) cashier in a bank takes off with a large sum of money and tries to use it up in a twelve-hour spending spree, making huge bets at a cycle-race, squan-

dering money on girls at a dance-hall, and finally scattering his banknotes to a frenzied crowd and shooting himself, after making a wild speech about the insanity of the money system. In Kafka's novel *The Trial* (*Der Prozess*, 1925), an individual whose name is reduced to the near-anonymity of the letter K, is pursued by the invisible authority of a legal and bureaucratic hierarchy. The prestige of the power system is sufficient to induce guilt feelings where no crime exists and to undermine all individual resilience. K ends up dying 'like a dog' at the hands of two hired killers, the victim of a social system which processes individual destinies like so many identical case-files. The society of anonymous exploitation is somewhat melodramatically portrayed in Lang's film *Metropolis* (1926), where the worker-slaves surrender their physical and spiritual resources to the demands of the city, manifested as the evil god Moloch which swallows human bodies, or as a vast machine within which the individual is reduced to the status of a negligible spare part.

A particularly virulent strain of dissent running through the art of the period has to do with the younger generation's disgust for an older generation which seemed to stand for all that was philistine, materialistic and life-denying. The theme of the idealistic son's abhorrence for his corrupt father crops up in an amazing number of literary works of the time. To cite a few instances: among the few identifiable individuals to emerge from the anonymous masses in *Metropolis* is the figure of the hard-hearted capitalist father who exhibits not a jot of sympathy for the humanitarian impulses of his tender-hearted son. Kafka's story *The Judgement* (*Das Urteil*, 1916) deals with a timid young man's confrontation with his widowed father, who, learning of the former's plans to marry and assume filial responsibility for him, springs up and accuses him of sordid manipulation. The father's counter-attack climaxes in a call for his son's life, whereupon the son obediently runs out to drown himself. Kafka's hatred of his own father could only find indirect expression in his fiction; even his *Letter to my Father*

(*Brief an den Vater*, written 1919) fails to spell out his hatred explicitly. (The letter, typically, was never actually sent.) Guilt throbs alongside hatred in the anguished sensibility, each passion complicating and exacerbating the other. The notion that his authentic self had been stifled is formulated by Georg Heym in an entry in his diary: 'I would have been one of the greatest poets, if only I hadn't had such a swine of a father.'[17] Walter Hasenclever's play *The Son* (*Der Sohn*, 1914) depicts an idealistic son who rebels against his establishment father, brandishing a pistol before him and provoking his death from heart-failure. It fell to the dramatist Arnolt Bronnen to dare to express what was surely the Oedipal desire of a whole generation when he wrote the play *Parricide* (*Vatermord*, 1915), in which the son at last gets to kill the father in the literal sense.

Violence of this order might seem symptomatic of a general youthful rebellion. And there is something a little adolescent in the way so many Expressionists try hard to demonstrate an affinity for those who have been thrust out of polite society. Drunks, beggars, thieves and street-walkers acquire a spurious glamour in Alfred Döblin's novel *Berlin Alexanderplatz* (1929), while Lang's thriller film *Dr Mabuse the Gambler* (*Dr Mabuse der Spieler*, 1922) invests the counterworld of criminals with a seductive radiance. A new script was being drawn up in which crime meant rebellion against the fundamental bourgeois values, as if thieves were really anarchist militants possessed of a vision of a better world on the far side of present property relations. The prostitute becomes a similar cult figure, saluted as the very incarnation of instinct and naturalness. In many of Kirchner's pictures, corrupt love seems to be designated as a modern cipher of authentic feeling, as if a paradoxical purity were to be discerned beneath the surface accents of decadence and immorality.

In essence, the Expressionist ideology of emancipation is built on the uncontested premise that subjective feelings have a kind of natural purity. To Franz Marc, it seemed that the very world had become poisoned and deformed by

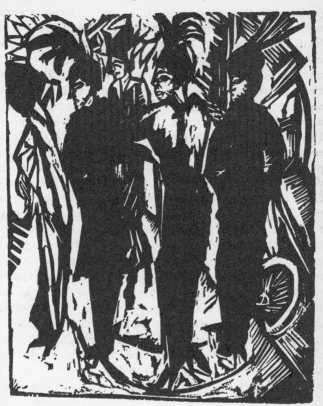

the positivistic modes of perception which contemporary society had sponsored. Reality was, so to speak, mutilated, and it needed a fresh vision to redeem it. In 'On the Question of Form' ('Ueber die Formfrage', 1912) – less a message about aesthetics than a manifesto of spiritual regeneration – Kandinsky writes of the 'Black Hand', the evil, negative principle which seeks to 'retard evolution and elevation in every way possible'. To it he opposes the liberating, constructive principle which he calls the 'White Ray' or the free spirit, alone capable of breaking down the stone wall of reactionary thought. For such an artist, the problem of aesthetic form was exactly equivalent to the

problem of spiritual values, and the implied message of his major treatise *On the Spiritual in Art* (*Ueber das Geistige in der Kunst*, 1912) is that the great deeds of avant-garde painting have the status of symbolic gestures of universal liberation. This attitude was, I think, typical. For while a good many minor Expressionists may be said to have campaigned for practical political changes, a significant proportion of Expressionist artists expressed their criticisms of contemporary society and their dreams of a better one in terms of an *aesthetic* revolution. Thus individual acts of free expression were presented as exhortatory glimpses of a utopia which, in practical terms, remained very intangible.

The regenerative strain in Expressionist ideology is concerned with both physical and spiritual reality. At the level of the body, there was a distinct call for emancipation, manifested for example in Frank Wedekind's outspoken play *Spring Awakening* (*Frühlings Erwachen*, first performed in 1906), where the scandalous theme of adolescent sexuality is brought into the open and given a name, as a means to attack the repressive moral systems of family and school. In another sphere, the liberated dancing style of Isadora Duncan may be taken as a complementary move towards stressing the inherent purity of the unconstrained human body, authentic in its nakedness and boundlessly fluent in its meanings. Her successor Mary Wigman was to refer to her own improvisations as 'nothing more than a confession of life brought into symbolic form . . . an acceptance of, an affirmation of everything that is alive and that will yield life'.[18]

This vitalistic message may be interpreted in lofty terms as a long-distance echo of Nietzsche's Dionysian celebration of the superabundant energy of the free will as it lays claim to unfettered pleasures. In more lowly terms, the Expressionist emphasis on bodily emancipation may be seen as reflecting a general contemporary craze for sport, open-air swimming, gymnastics, cycle-racing, rambling, camping, nudism and the like.[19] Yet within this general current, Expressionism gave to the freedom of the body the symbolic

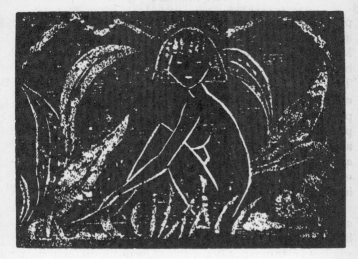

meaning of a spiritual liberation. After all, the Expressionist definition of expressive gesture is that it is an outflow of spiritual impulse. So that when the Bridge artists went bathing with their girlfriends at the Moritzburg lake and then went on to produce paintings of nude bodies in water or amid foliage, all in bold lines and fearless colours, they were mounting an attack on repression in both literal and symbolic terms.

I would suggest that while pre-war Expressionists were preoccupied by the myth of the individual sensibility maximizing its private expressive resources, the post-war artists swung towards a myth of collective renewal. The anguished singular thus modulates into an exuberant plural, with poets turning up the volume on their personal communication and broadcasting to an imagined multitude of eagerly attuned comrades. 'My sole wish is to be related to you, O Man!' exclaims Franz Werfel in his poem 'To the Reader' ('An den Leser'), which ends with this pious prayer:

> O if only it might one day happen
> O brother, that we should fall into one another's
> arms![20]

57

An appeal to what Alfred Wolfenstein rapturously terms 'that sweet near-and-far camaraderie!' may fall rather flat on our less idealistic consciousness. None the less, it became a central tenet of Expressionist doctrine that those feelings which might at first seem to be intrinsic to the individual should, on the contrary, rather be seen as radiating outwards in forms accessible to kindred sensibilities. 'Each life is lived a thousand times in a thousand other lives', writes Paul Zech happily.[21] Hence the old notion of expression as spontaneous psychic impulse evolves into a model of unimpeded universal meaning, as though the voice of the single subject were by definition in tune with an entire choir.

This Expressionist principle of universality did not however mean that *any* arbitrary member of the social whole was automatically capable of inspiring all other men. Alongside the publicly avowed ideal of universality there survived a more or less élitist (and romantic) myth of the artist as an exceptional and exemplary being – one who feels more intensely than others at the same time as he feels in ways which are not alien to others. Seen as at once the equal of everyone else *and* an example for everyone else to look up to, the Expressionist artist assumes the mantle not so much of Everyman as of Nietzsche's Superman, the champion of creative individualism in the face of conformity, and prototype of an emergent 'New Man'.

Just such an heroic exemplar is projected by Georg Kaiser in his historical play *The Burghers of Calais* (*Die Bürger von Calais*, written in 1914) in which the town of Calais, besieged by the English, is offered the chance of being spared, provided it offers up six citizens in sacrifice. The six duly declare themselves, but a seventh, the superlatively noble Eustache, manages to kill himself first. His grand gesture is seen as a sacrifice that will radiate in the spirits of his fellow-citizens, and inspire in them a desire for moral regeneration; it meanwhile earns the town its liberation from the equally admiring English. The play is typical of Kaiser's crusading purpose, reflected in one of his

maxims: 'When one leaves the theatre, one knows more about the potentialities of Man'.[22]

The post-war ideal of the New Man is one that can easily degenerate into cliché. Kurt Heynicke's 'O Man, into the light!' (*'O Mensch, ins Licht'*!), Johannes R. Becher's 'Man – stand erect!' (*'Mensch stehe auf'*!) and Ernst Stadler's 'Man, become thy essence!'[23] are appeals not so much to a defined programme of social regeneration as to the haze of sentiment which accrues around an inflated watchword: *Mensch* (man, mankind). All the same, there were genuinely sincere attempts to hasten the advent of an 'epoch of great spiritual-ity', as Marc and Kandinsky called it, including concrete projects of a collective educational kind.

One such enterprise was the November Group of revolu-tionary artists, founded in Berlin and named after the revolution of November 1918 which had brought about the downfall of the Emperor and an end to the war. It was soon to merge with a kindred association, the Workers' Council for Art. Both groups attracted the loyalty of the Bridge artists Pechstein, Heckel and Schmidt-Rottluff, and the architect Bruno Taut. Pechstein threw himself the most spiritedly into the endeavour, designing a cover for a pamphlet addressed 'To all Artists!' which shows an anonymous (but obviously 'new') man struggling forth in front of a city, flames of revolution-ary fervour leaping from his visible red heart. One manifesto of the November Group speaks of its ambition to transcend all class distinctions in a joyful creative collaboration of human and artistic convictions, thus combining 'unlimited freedom of expression' with 'the collective well-being of the nation'. Such efforts went a long way towards defining a pro-gramme of ambitious educational reforms, and contributed to a nationwide revolution in the public sector of the arts. Mu-seums were at last encouraged to invest in modern paintings, and art schools began appointing leading Expressionists to their staff. Expressionism suddenly found itself almost the official state doctrine in matters creative – a situation which lasted only for a short time in a country still too devastated to achieve cultural or moral renewal in any stable form.

It is worth also noting the educational initiatives of Mary Wigman, whose Central Institute was founded in Dresden in 1920 and whose pupils carried the principles of the New Dance Movement abroad, most notably to America. The Bridge artists had made a short-lived attempt to found a school for modern painting before the war, the MUIM Institute (its initials refer to the phrase 'modern instruction in painting'). Now, major Expressionist artists like Kandinsky and Klee were to join Walter Gropius's pioneering establishment, the Bauhaus, perhaps the most assertive educational venture to derive from Expressionist impulses. That the school survived for fourteen years in a Germany collapsing under inflation and eventually succumbing to barbarism in the shape of the National Socialist take-over is remarkable enough. What must be emphasized here is that although Gropius's enterprise shifted away after a few years from an Expressionist to a formalist or geometric 'house style', it consistently upheld that dual postulate central to the Expressionist position, whereby the development of creative potential in the arts must go forward in step with a process of moral refinement, based on self-knowledge and ethical integrity. The early Bauhaus syllabus comprised a foundation course run by the painter Johannes Itten which thrust the student into a confrontation with his own creativity outside academic guidelines. The practice of what we might today call 'free expression' in a variety of media was part and parcel of an essential Expressionist vision of the value of spontaneous concourse with the self.

For all these efforts to direct its energies transitively, so as actually to *make people change*, Expressionism was, in the final analysis, a movement whose most sincere ambitions were never fully concretized. A fundamental discrepancy between idealism and material achievement – in more emphatic terms, between the unconditional space of the imagination and the contingent domains of social and economic life – meant that its impact as a movement was, in the long term, more utopian than actual. Symptomatic

of the movement's loyalty to perfect principles (or failure to compromise) is the story of Expressionist architecture.

I have suggested that the dance is a 'natural' medium for Expressionism, inasmuch as it involves the impulses of a single sensibility defining its own expressive space. Architecture, on the other hand, has, inevitably, to take issue with space as something shared by a multitude of bodies, and thus to modify expressivity with respect to collective expectations. Architecture is surely the most socially-oriented and materially constrained of arts, and it therefore makes sense to take Expressionist architecture as the test-case of how far the ideals of the movement – involving a delicate interplay between singularity and collectivity – were able to assert themselves in real-life practice.

There is little to say about Expressionist architecture of the pre-war period, except that the founding members of the Bridge group – Kirchner, Heckel, Schmidt-Rottluff and Fritz Bleyl – were all architectural students. Only the last-named went on to complete his studies, so that the Bridge attitude would seem to imply a concerted effort to invest energies in spontaneous painting as something un-taught (indeed, unteachable – which perhaps helps to explain the failure of the MUIM Institute), and thus distinct from the systematized discipline of architecture.

Yet the situation in German architecture in the 1910s was curiously conducive to a new departure. A stylistic crisis was indeed already manifest, as two broad tendencies came into play. On the one hand, art nouveau experiments had encouraged a fluid, fanciful approach which, though limited to decorative rather than structural innovation, had helped to establish fantasy as a valid constituent of design. On the other hand, technology was offering a range of modern materials which seemed to dictate a more severe style. Steel girders, reinforced concrete and sheet glass might be expected to conduce to a style of functionalist austerity: in very broad terms, such was to be the style which the Modern Movement would impose on European

architecture in the following decades, a style in which fluidity and caprice were effectively outlawed.

For a moment, though, Expressionism was able to achieve a precarious synthesis of the fluid and the functional. Under the influence of Expressionist ideas coming from the visual arts, architects like Walter Gropius and Bruno Taut sought to make use of the new materials in ways which gave priority to imagination over practicality. When each designed a pavilion for the 1914 industrial exhibition in Cologne, Taut in particular seized the opportunity to demonstrate the potential of glass as the modern medium *par excellence*, producing a kind of circular beehive of multi-coloured glass tiles. High on a circular platform inside, visitors could feel themselves magically suspended above the world of physical and moral gravity, as a cluster of rotating lenses threw rays of coloured light on to all surfaces. Taut's Glass Pavilion was built to display glass-ware: it was itself a monumental expression of the fluency and spiritual resonances of glass crafting.

Taut was the animator of a loose group of architects with an affinity to Expressionism whose activities included the regular exchange of 'utopian letters' and the publication of a review called *Early Light* (*Frühlicht*, 1920–22). A number of design projects were organized through the auspices of the Workers' Council for Art, and two major buildings may be cited as representative of such initiatives. One is the Einstein Tower (1917–21) at Potsdam, designed by Erich Mendelssohn, a young member of the November Group. This structure was an observatory. Though built of reinforced concrete, its forms are highly fluid, with curved surfaces coiling about the central tower and windows set around any right angles to soften angularity into rhythmic flow. The other building is Hans Poelzig's Grosses Schauspielhaus (1919) in Berlin. Whereas the Einstein Tower seems to echo the flow patterns of whipped cream, the interior of Poelzig's theatre is like an architectural simulation of an underground cavern with thousands of stalactites hanging from the ceiling.

Aside from a smattering of less extreme buildings, such as Fritz Hoeger's brickwork Chilehaus in Hamburg (1922–23), and projects pursued outside Germany by architects such as Michel de Klerk in Holland and P. V. J. Klint in Denmark, these two structures stand out as the only fully convincing examples of an Expressionist architecture in concrete form. What characterizes them is clear: a more or less biomorphic approach to the way the building will shape up, allied to an uncommonly daring implementation of the structural possibilities of steel and concrete. Of course, the tension between an expressive impulse towards organic fluency and a common-sense concern for structural stability may be seen as the model for any architecture of an imaginative cast. Expressionist architecture simply goes to the extreme in asking that emotive gesture be given priority over calculation. Sadly, this visionary moment was short-lived, for financial resources in an inflationary economy dwindled fast, preventing any further projections of fantasy. Consigned to the drawing- board without prospect of commissions, those few architects who valued expression above compromise continued to work, producing designs which, given that practical execution was denied anyway,

became more and more emancipated and fantastical. The furthest extreme of this tendency is the work of Hermann Finsterlin, whose sketches for factories, studios and dwellings abandon all pretence of practicality and take off in the direction of a kind of science-fiction paradise of nameless forms, part fluid, part vegetal. As for Taut, he managed to get himself appointed director of city planning in Magdeburg in 1921; allocated too small a budget during his two years in office to be able to do any actual building, he had to content himself with decorating the walls of public edifices in abstract patterns with bold colours, a more or less symbolic gesture towards leaving an Expressionist imprint on a modern city.

In terms of actual buildings, Expressionist architecture can hardly be called a runaway success. But it is precisely in the perspective of its literal failure that it may be worth attending to its status as example. Certainly the abundance of 'intransitive' schemes and theoretical statements represent a significant corpus of creative production, and it could be argued that it is here that success of a different kind can be found.

The outstanding theorist remains Bruno Taut, whose various books about architecture constitute a most striking, if utopian, contribution. Taut had been influenced by a book called *Glass Architecture* (*Glasarchitektur*, 1914) by the science-fiction writer Paul Scheerbaart, and had developed a passion for glass that went far beyond its technological significance. For Taut, glass is the embodiment of light itself, hence of spirituality: he sees glass architecture as necessarily the style of a future society in which a pure spirituality will be restored to man.[24] And where will the New Man want to spend time, if not alongside his fellow New Man? Taut's ideal building takes the form of a vast cathedral or public pagoda, a place of spiritual inspiration and communal contact. In books like *The City's Crown* (*Die Stadtkrone*, 1919) and *The Dissolution of Cities* (*Die Auflösung der Städte*, 1920), he busied himself with schemes for socialist New Towns in which almost every building would have a

public purpose, a huge 'House of Crystal' being situated at the centre of the town as the symbolic locus of an integrated society. Eventually Taut saw the whole of Europe turning into a selfless brotherhood made up of workers' communities, shaped like stars and linked by aeroplanes. In this classless society, people would work joyously and live together in crystal houses heated by solar panels, with no thought of property.

The most far-fetched of these parabolic works is *Alpine Architecture* (*Alpine Architektur*, 1919), in which Taut seems to make an unconscious association between the crystalline ideal embodied in glass architecture and the structure of snow crystals. Since snow is found in mountains, which are also lofty and cathedral-like forms, what better place in which to develop the new architecture than the Alps? In a series of watercolours, Taut shows how the natural topography of rock, glacier and snow might be improved, indeed perfected, by the addition of structures of steel and glass. He envisages capping the very peaks with buildings of radiant symmetry, with bridges spanning the glaciers, huge glass sculptures, and coloured search-lights tracking over the snowfields. In this world of the 'Crystal Mountain', Taut argues, man will rise above contemporary decadence, transcend class and national boundaries and enjoy a life of exhilaration and dignity. 'Our dawn glows on the horizon,' he insists. 'Hail to transparency, to clarity! Hail to purity! Hail to the crystalline, hail and hail again to the flowing, graceful, faceted, sparkling, flashing, airy – eternal building!'[25]

Here is evinced a persistent utopian reflex dating back to the romantic period, which impels the artist to react to practical disappointment by postulating a better world on the far side of what is literally visible. As I have suggested, the Expressionists did have their faces pressed close enough to reality to know that idealism is not enough in a vacuum. And they were, I believe, generally eager to participate in some form of collective action which would militate for an improvement of man's material as well as spiritual life. Yet,

in the final analysis, their influence on the circumstances of immediate history did not run very deep. Judged by its own high expectations, Expressionism cannot be thought to have achieved much by having intervened in the education of one or two students, or having put up one or two isolated structures. 'There must be something alive in each human breast which elevates man above the temporal,' writes Taut.[26] The utopian vision is one which seeks to overcome the limitations of circumstance by focusing on a reality beyond what is immediate. In this sense, Expressionism makes its stand as an effort to step outside history.

Let me repeat myself, to be sure that the stress is right. No one would deny that suffering is a very non-conceptual experience, and that there is an irreducible thematics of pain and hence a fundamental existential ground to Expressionist aesthetics. In the first chapter I argued that it is a primary concern of Expressionists to seek to tie expression to life, by an 'indexical' linkage between creator and work, within which the responding spectator is also expected to be bound. At a secondary stage the Expressionist may be tempted to situate his works not only within his specific personal biography, but within a specific historical situation, the collective biography of his generation or society. Now I want to move beyond these existential or circumstantial perspectives and consider the Expressionist project in what I take to be its ultimate manifestation, as an attempt to transcend contingent circumstance – to step outside history – and in so doing to lay hold of essences and eternal certainties. If art is, in Kaiser's formula, the 'expression of the idea which is timeless and omnipresent',[27] then the thrust of the project is, at the extreme limit (and who would expect an Expressionist to hold back from limits?), an effort to travel beyond the dark world of painful surfaces and shifting appearances in a spiritual quest for a luminous realm of transparent universality. What might be termed the 'mystical' purpose of Expressionism is to grapple with the many contraries implied in the expressive

posture – inner feeling/outer gesture; pristine intention/ flawed performance; ecstasy/pain; singularity/collectivity – and to achieve their triumphant resolution, a spiritual transvaluation of the rough-cut raw material of material experience, of immediacy. In identifying Expressionism as a struggle to glimpse, in Marc's phrase, 'things as they really are, behind appearances', or again, more forcefully, as a rebellious invasion of what Iwan Goll once called 'the reality behind reality', I am aware that I am laying considerable stress on the 'intangible' side of Expressionism. It is because I feel that these spiritual or utopian strands lead to the very heart of the truth about Expressionism that I want to devote a separate chapter to their fuller definition.

III
THE SPIRITUAL
IMPULSE

Kokoschka once called consciousness 'a sea ringed about with visions'.[1] The Expressionist subjectivity is typically one which gives priority to the impetuous and unconstrained impulses which spring from deep within the formless core of the psyche. If rational thought is often conditioned by pre-existing mental structures, thus tending to reaffirm the basic pattern of what has been already thought, the outpouring of primary material of an emotional or irrational kind brings to the expressive moment a note of unpredictability and caprice. The 'dreamlike inner life' of which Kafka speaks is capable of producing colours and figures whose power to impress is so much greater than the grey contours of ordinary perception. As the romantics had declared a century before, dreams are the elective medium of the imagination in its quest for insight into a deeper, more absorbing dimension of reality.

Many works of Expressionism seem deliberately to seek out the effect of dreams, if not of nightmares. Strindberg's *A Dream Play* (1902), with its disjointed and yet oddly consistent incidents, represents a kind of stage transposition of what Freud calls the 'dream work' of the sleeping mind. The poems of Georg Trakl often read like dream transcripts, veritable scenarios of unconscious process, with their unannounced intrusions, adjectival incongruities and uncanny half-explanations.

Evening in Lans
Wandering through the twilight summer
Past sheaves of yellowed corn. Below whitewashed
 arches

Where the swallow flew out and in, we drank fiery
 wine.

Beauty: O depression and purple laughter.
Evening and the dark scents of green
Cool our glowing forehead amid shivers.

Silver waters trickle across the levels of the forest,
The night and, speechless, a life forgotten.
Friend; those leafy footpaths into the village.[2]

In the text, incidents are offered with little comment, in a
succession of observations touched with what seems a
uniform colouring of pleasure and summery fullness. Here
is the natural world, and its inhabitants seem at ease. And
yet there is an air of foreboding: obscure smells cause
shivering, waters gleam below the dark trees, a whole life
slips by unexpressed and unremembered. As readers, we
may be lulled into a sense of cohesion and tenderness and
then wake with a start to the realization that this seductive
landscape is lacking in any clear-cut figures – it is a dream
setting with no real faces we can identify.

Kafka once recorded in his diary a genuine hallucination,
when he saw a white horse just before falling asleep: 'I have
an impression of its first stepping out of my head, which was
turned to the wall, jumping across me and down from the
bed and then disappearing.'[3] Alfred Kubin wrote a com-
plete novel called *The Other Side* (*Die andere Seite*, 1908),
whose action is set in a dream-city called Pearl. And
Munch's paintings of distraught figures immobilized in the
midst of hysteria-drenched landscapes have all the charac-
teristics of dreams or hallucinations. It is as if there were an
irresistible connection between the Expressionist's intent to
depict feeling and a style reminiscent of dreaming. When
Marc visited Paris in 1907 to see 'the wondrous works of
van Gogh', he wrote: 'Art is nothing but the expression of
our dream; the more we surrender to it, the closer we get to
the inner truth of things, our dream-life, the true life.'[4]
Though Marc and other early Expressionists were sensi-
tive to impressionist painting – Kandinsky for one had been

bowled over when he saw Monet's painting *Haystacks* while
still a student in Moscow – it was not because they had
any time for the 'official' impressionist doctrine of fidelity
to the phenomenal, but because they already sensed an
implied movement away from the priority of overt subject-
matter. The success of the label 'Expressionist' was largely
due to a crude but critically telling contrast which critics
of the period forced upon the two movements: impression-
ism was seen as restricted to the scientific reproduction of
the play of light upon visible objects, while Expressionism
was concerned with reaching for the numinous,
non-perceptual aspect of things. This distinction can be
roughly exemplified by comparing two paintings by van
Gogh, one in the impressionist style, and the other in his
late, Expressionist manner. The light-hearted rendering of
an *Orchard in Blossom* ((*Souvenir de Mauve*,) 1888) transmits
the impression of sparkling clusters of pink petals flicker-
ing in a breeze; to be sure, there is no lack of feeling in the
painting, but the power of the image relies on a visual
reference to the way peach trees actually look in spring-
time. Conversely, the later *Cypresses* (1889) are painted in
thick undulating strokes of sombre green which seem to
suck in rather than to give off light: the trees are no longer
consistent with our retinal impressions of cypresses, but
have become the heavily accented embodiments of some
new spiritual meaning.

Almost every Expressionist painter insists on this fun-
damental shift in emphasis from an eye-centred (or textu-
ral) to a spirit-centred (or essentialist) approach to the real
world. 'Mythic observation is to me the foundation of all
art,' writes Barlach, adding that 'having visions is the
capacity for sensual sight'[5] – seemingly an affirmation of
the artist's preference for trance-like states of absorption in
perceptual experience, as opposed to intellectually-
governed states of critical distance. Nolde writes in his
autobiography that 'for me, the highest value, the form of
visible life, was always inward and spiritual'.[6] Similar
phrases can be found in the writings of practically every

Expressionist artist. What are the implications of this terminology of visions and spiritual insight?

I mentioned earlier that the Blue Rider Almanac, drawn up by Kandinsky, Marc, Macke and others, contains a large number of unorthodox pictures – glass-paintings from the Bavarian villages, wood-carvings from black Africa, drawings by German school-children and so forth. All these constitute examples of internally-oriented vision, works produced by creators truly in touch with 'the secret of their sensations', as Macke puts it, and oblivious of the ruling of European academic painting which said that appearances must be respected. A concentration on the interior reality of phenomena becomes a watchword of Expressionist aesthetics, informing even the attitude of a film-maker like Paul Leni, who, evidently seeing cinema as being no less emancipated from an eye-oriented stance than painting, asserts roundly that 'it is not external reality that the camera perceives, but the reality of the inner event, which is more profound, effective and moving than what we see through everyday eyes'.[7]

Kandinsky it was who produced the manifesto of visionary Expressionism in his essay *On the Spiritual in Art* (1911). Here Kandinsky argues that the aim of the visual arts must no longer be to reinforce the values of a society long since stupefied by the dead weight of materialism, but to re-align painting with man's spiritual needs, drawing form out of an act of communion with the inner spirit. Through expressive gestures which transcribe essential visions in the dynamic idiom of colour – an idiom of abstraction, as I shall shortly show – the artist will supersede the object-bound ambitions of mimetic art and enter, borne on an ennobling pulsation of genuine expressive power, upon a higher dimension of Being. In Kandinsky's lyrical terms, the artist thereby becomes the medium of the White Ray of spiritual regeneration that will disarm the Black Hand of materialism.

The contributions which Kandinsky and Marc made to the Blue Rider Almanac are couched in the most fervently messianic terms. 'We are standing at the threshold of one of

the greatest epochs that mankind has ever experienced, the epoch of great spirituality,' runs one editorial under their joint signatures.[8] The Blue Rider enterprise, with all its busy publications and exhibitions, was seen as a contribution to a vast international movement of spiritual renewal in which art was in the vanguard position. The inheritance of the past had been used up; it was now time to strike out into the virgin territory of a new age.

Given the model of the Expressionist subject attuned to its internal impulses, this conception of a spiritual awakening seems to emerge naturally from an act of radical ontology, whereby the subjectivity tears itself free of the corrupt influences of social and institutional programming so as to gain access to its repressed core of primal creativity. The primitivistic taste of the Blue Rider, as indeed of the Bridge group – the wilful rejection of any categorical distinction between European 'high' art and primitive art in the widest sense (folk art, naïve art, tribal art, child art, even psychotic art) – comes across as an integral component of an aesthetics of subjective impulse, ungoverned by any objective rules.[9] The corollary of this vision of the continuity of inner spirit and form-giving gesture is a concomitant faith in the virtue of works produced out of specific kinds of states which it becomes the artist's vocation to facilitate within himself. Let us look at some of these.

When a relatively non-cerebral painter like Nolde writes in such rapturous terms of his 'yearning for impossible joys, a yearning for life beyond measure, for a beauty vital and flourishing, for everything grand and glorious',[10] he seems to be implying that the creation of expressive works of art is fundamentally conditioned by such feelings as these. I dare say Nolde would not deny that having an eye for colour and some skill in tracing outlines is an advantage: but what he insists on as the *sine qua non* for authentic acts of creation is this state of projective urgency, this longing which is effectively a thrusting of the spirit beyond what is given here and now. Once more the expressive model is adjusted: here the movement of turning to one's innermost resources is

reversed, so that the subject begins to scan the space *beyond* its own immediate orbit, in search of impulses which are no longer ones it has initiated, and which it receives as a more or less passive recording instrument.

This new step in the artist's expressive approach is literally a 'stepping out' from the enclosure of subjectivity. *Ecstasy* is just this – a condition of sublime carelessness about the boundaries of the self. It is as though Expressionist anxiety were at last alleviated, or rather, superseded by a superior mode of expectancy or yearning. Hitherto, the subjectivity facing up to the world ran the risk of exposing itself to the cruel effects of social and material reality. Now, in an act of supersession, that same opening-up of self to the non-self takes on a wholly fresh colouring. Sombre angst gives way to bright astonishment, as the subject's relationship to what lies beyond it is renegotiated. And in the mode of ecstasy, the expressive act *par excellence* is one of *stepping out* from one's core of private feeling into what might be called mystical feeling or a sense of transcendent interconnectedness.

The ecstatic moment is frequently evoked as a key experience for Expressionism. Mary Wigman maintains that it is the indispensable factor in any truly expressive movement of the body: 'Without ecstasy there is no dance.'[11] In this 'Creative Credo', Max Pechstein describes his preparation for painting as an exhilarating projection of energies on to the canvas, in which subjective reticence and inert pigment are posited as the raw material out of which the ecstatic impulse fashions its own creative design: 'Work! Ecstasy! Smash your brains! Chew, stuff your self, gulp it down, mix it around! The bliss of giving birth! the crack of the brush, best of all as it stabs the canvas. Tubes of colour squeezed dry.'[12]

Violent this may sound, but it is now a positive rather than a negative violence: the creator is giving birth, not violating. And in the sphere of the erotic, a complementary revaluation of outgoing energy can be identified. In my last chapter, I made reference to that moment of self-expression

73

when the self faces the other in the sexual encounter and, fearful of dissolution, protects its integrity by striking out aggressively. If we now imagine such a moment being replayed in a context of confidence and positive feeling, the self may seem only too eager to surrender its integrity and to dissolve in blissful union with the other. These lines from Stramm's 'Twilight' ('Dämmerung') exemplify this sense of abundant compensation, the vulnerable exposure of subjectivity being at once redeemed by a sense of bliss and plenitude.

> Bright repels Dark!
> Dark gobbles Light!
> Space drowns in loneliness
> the soul
> bubbles
> boggles
> Stop!
> My limbs
> Are spinning
> in immensity
> Thou!
>
> Bright is Light!
> Loneliness slurps!
> Immensity cascades
> Rips
> Me
> In
> Thou!
> Thou![13]

Erotic ecstasy can be seen veering into sheer inarticulateness: once formal referentiality is abandoned, the reader can only guess that the subjectivity in question is experiencing some form of rapture of astonishingly pleasurable proportions. The capacity of ecstatic feeling to summon divergent sorts of vocabulary unto itself – as if it were the magnetic locus of Being or Life itself – has as its consequence a typically Expressionist widening and blurring of focus. Theodor Däubler contends that 'authentic life can only be grasped in ecstasy',[14] and it might not be wrong to adapt this

formula and establish an Expressionist motto, 'Ecstasy is the quintessential state to be in if you want to be authentically in touch with life.'

If it is indeed the case that ecstasy is the privileged medium of Expressionism, it comes as no surprise to find that a given single stimulus should be the occasion for a generalized euphoria of a mystical kind. Ernst Stadler writes in one poem that 'I want to press my being into every direction as far as it will go',[15] and his most famous poem, 'Crossing the Rhine Bridge at Cologne by night' ('Fahrt über die Kölner Rheinbrücke bei Nacht'), is a perfect example of a specific experience – a nocturnal crossing of a railway viaduct – giving rise to the most broadly universalized themes. The singular subject here shows a propensity to stretch itself out, in a rapturous expansion of consciousness that embraces pleasure and pain indiscriminately, finally to dissolve in a simultaneous celebration of all things, a merging into Creation at large.

> We are flying, lifted high like kings across the air
> ripped out of night, high over the mighty river. O
> curving of a million lights, silent sentries,
> Before whose glistening cavalcade the waters rumble
> heavily down. Endless display set out by night in
> greeting!
> Thronged like firebrands! Joyousness! Salvoes from
> ships on blue waters! Starry festival!
> Teeming, thrust forward with brilliant eyes! Until the
> city's edge where the last houses take leave of their
> guest.
> And then the long solitudes. Naked riverbanks. Hush.
> Night. Awareness. Intimacy. Communion. And
> exhilaration, and urgency.
> To embrace the ultimate, which gives blessing. The
> rite of procreation. Lust. Prayer. The ocean. The
> plunge.[16]

Spiritual exaltation at this pitch modulates into a yearning for a condition which transcends the limits of ordinary perception. Such a tumult of excessive yearning can imply a

desire for the extinction of all personal boundaries, that is: the supersession of the singular individual.

Taking their lead from pre-Expressionists like Dostoevsky and van Gogh, several Expressionists opt for an apotheosis coloured by Christian associations whereby the humble believer abandons himself utterly to the cosmic embrace of the divinity. Certainly Ludwig Meidner, whose early work had been an agitated celebration of the cataclysmic themes of the Book of Revelation, was to turn by 1918 to the rest of the Bible, seeing in it an ennobling inspiration, 'a source of endless joy and profound truth'.[17] In poetry, the ecstatic voice may modulate into the tonality of prayer, addressing the cosmos in the second person and thereby aligning Expressionist ecstasy with the traditional religious theme of the puny believer watched over by an almighty God. These lines from Paul Zech's poem 'I sense you there' ('Ich ahne Dich') illustrate this position.

> I sense your presence, I feel you there, yes you, O
> Power,
> Are truly there, and more intense than ever I
> expected.
> And already you are drawing out over me that star-
> sprayed
> Face with eyes a thousand years old.[18]

Emil Nolde was to paint a series of works inspired by the Bible: *The Magi*, *The Last Supper*, *The Crucifixion*, and so on. Unfortunately for that evidently pious and sincere artist, both the Protestant and Catholic churches refused to have any truck with his works, finding them altogether too disquieting to merit official recognition as religious paintings. Indeed, their caution was justified, given that Nolde's bold Expressionist mixture of patches of insistent colour and ravaged lines could well be said to function more as an attack on the spectator's sensibility than as an invitation to peaceful contemplation. Despite his avowed dedication to Christian values, a kind of instinctual paganism seems to assert itself in Nolde's work, as witness his paintings of the

Old Testament subject *The Dance round the Golden Calf* (1910), in which figures painted in riotous colours seem to be celebrating a form of ecstatic feeling which looks more like an incitement to sex than to prayer.

My assessment is that while there is evidence of orthodox Christian beliefs being operative among a number of Expressionists, the current of metaphysical feeling which runs through the movement at large is rather less than specific. When Jawlensky writes of 'that fleeting contact with the soul of things, with that Something, unsuspected and ignored by all, which trembles in every object of the material world, in every impression that we receive from outside ourselves',[19] he seems, in the very hesitancy of his definition, to be alluding to a power which lies beyond known Christian definitions. We should, indeed, remember that the Expressionist artist is temperamentally drawn to experiences in which the resources of individuality are – somehow – safeguarded. And so, even though he may be tempted by the notion of the self dissolving in ecstatic union with the cosmos, he may equally want to re-assert his individuality in the face of this excessive act of abandonment. That is, the singular subject may like to flirt with the spectacle of its own extinction within a greater whole, yet it also likes to rehearse that extinction more than once, and after each brief engagement with ecstasy, to retreat back to the old definition of its unique and specific identity.

A passage from a letter of Kirchner may illuminate these positions. Kirchner speaks of the artist who creates his own world (the model being that of singular expression, the created object which belongs entirely to the individual) and of his concomitant effort to make contact with a mystery lying beyond the individual (the model shifting to that of the created object as lens on to the non-self).

The great mystery which lies behind all circumstances and things in our environment can often be seen or felt in a schematic form – while we are talking to a person or standing in a landscape, or when flowers or objects suddenly begin to speak to us. Just think: a human being is sitting across from us when all at once there

surfaces something entirely intangible in a conversation dealing with his private experiences. It imparts to his features the most deeply innate personality and yet, simultaneously, lifts those features beyond the personal. If I am successful at entering into contact with him in what I might call this experience of ecstasy, I can paint a portrait. And yet this portrait, however much a likeness it is, is only a paraphrase of that great mystery. In the last analysis it will represent not the individual personality, but a part of that spirituality or feeling which pervades the whole world.[20]

The passage is interesting in that Kirchner is arguing for a mysticism which, so to speak, has it all ways. There is a mysterious impulse to attend to an invisible Something which transcends the individual and pervades all reality. The artist seems to be the privileged medium through which this awareness is channelled. Do other people have such experiences? If they do, then only in an inarticulate, unexpressed way. It is up to the artist, who presumably also enjoys a more acute awareness than others, to lay hold of his intuitions in the form of acts of expression. Such expression is inevitably only a paraphrase of the Something which appears in schematic form, a signal of a potential direction which doesn't necessarily imply a departure. Crucially, in this instance, Kirchner focuses not just on a landscape or a flower, but on a human figure. Almost despite himself, he seems to submit to a conventional academic reflex and to concern himself with the mimetic plausibility of his portrait. He does indeed aim to establish a strong resemblance between the sitter and the painted face. Even so, we are not really concerned here with iconic or mimetic accuracy. Something deeper, more spiritual, is at issue. What Kirchner wants to suggest is that the features of the painting take on an aura which is *symbolic* of the personality of the sitter, as opposed to being simply a set of visible marks which accurately replicate the shape of his face. And finally, those painted features take on a wider radiance of meaning, in that they become, to use a favourite word of Kandinsky's, 'vibrations' registering the presence of a deeper, trans-personal state of being.

Such a case, it seems to me, embraces all the impulses of Expressionist art and holds them in creative tension. Kirchner wants to be the expressive subject in sole control of the situation. He equally wants to open himself up to the impulses which transcend him, that is: he wants to perform 'ec-statically'. His idea of the portrait is that it respects individuality without actually sticking to visual appearances. And, at the same time, individuality modulates into some kind of potent, non-individualized spirituality. My reading of this extract is that it describes a miraculous simultaneity, for it seems that painter, sitter and portrait all enter into the dimension of transcendence while *at the same time* remaining acutely conscious of an exactly contradictory state in which identity remains fixed and recognizable. This combination of the general and the particular, this union of the universal and the monad, is, I would suggest, a characteristic paradox of Expressionist thought (if indeed it may be said to be grounded in conceptual terms!). I want now to pursue this paradox with specific reference to one of the most popular subjects in Expressionist paintings, landscape.

Opening oneself up to the stimuli of the natural world is an activity closely associated with that emancipation of the body of which I spoke above. Much of the boisterousness of the early Bridge landscapes may be a reflection of those distinctively *open-air* activities which accompanied the group's artistic experiments – swimming, sunbathing, lovemaking. Pechstein's reminiscences of the long summer of 1910 spent by a lake outside Dresden suggest an idyllic unison of artistic creativity and sheer animal fun. But underlying this interaction of art and physicality is a current of celebration and astonishment, of awe at the intensity of an experience of participation in the cross-play of natural rhythms. On one level, this participation is like a replay of van Gogh's rapturous discovery of Provence when he went from Paris to Arles in February 1888, travelling in a few hours out of gloom and into the most overwhelming sunlight; or again of Gauguin's almost mythical journey to

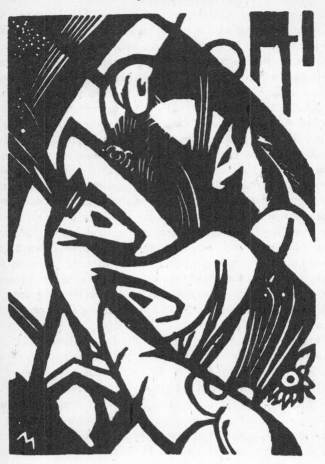

Tahiti, another sun-drenched habitat, this time peopled with graceful naked girls, which inscribed itself on to canvases replete with an air of warmth, security and boundless sensation.

At another level, the contact between the Expressionist sensibility and nature begins to manifest itself in terms of a reciprocal awakening. Franz Marc above all epitomizes the Expressionist in the posture of tremulous discovery – of his

own inner spiritual impulses and of corresponding impulses in the virginal world outside. Seen through the eye of feeling, the world of plants, rivers and animals takes on for Marc the consistency of an untouched, crystalline Eden – a visionary reality whose essence cries out to be transcribed in paint. In his writings, Marc describes his conception of artistic renewal as 'a re-birth of thought', an entirely fresh outlook on life, or rather an entirely fresh apprehension of the subject's relationship to phenomena. Marc saw himself as being in a position to give definition to that 'unearthly Being which lives behind everything',[21] and in a rich series of paintings of such subjects as mountains, horses and deer, he presses forward in an effort to transcribe 'the inner mystical structure of the world'.[22] Marc's mysticism is really a form of animism, an ecstatic recognition of the world as being alive with invisible vibrations imperceptible to the limited sensibility of civilized man; in line with a tradition of antagonism to culture and loyalty to nature which dates back to Rousseau, Marc proceeds to identify his own creative work with the way wild animals perceive the world.

I could see the image that breaks up as the coot dives underwater: the thousand circles which enclose each tiny living organism, the blue of the whispering sky which is swallowed in the lake, the delight of coming up to the surface in a different spot – know now, my friends, what pictures mean: coming up to the surface in a different spot.[23]

Participation in non-human life brings the Expressionist into a direct encounter with the natural world – 'person to person', as Barlach once put it, as if to look at nature openly and without preconceived expectations were like 'tearing the veil from the face of a mysterious person'.[24] Kandinsky in turn speaks of experiencing the 'secret soul of all things', of cultivating an 'inner seeing' which can penetrate the surface of the world and 'allow us to apprehend the inner pulsation of things with all our senses at once'.[25]

I shall not try to analyse further these artists' claims to

81

have apprehended Something which I must assume – on the basis of intuition, since conceptual clarity is hardly possible – is in fact the same thing, be it labelled 'indivisible Being' (Marc), or 'that Something which trembles in every object of the material world' (Jawlensky), or 'the secret soul of all things' (Kandinsky), or 'the living features of eternity' (Barlach) or 'primal essence' (Nolde). Let me simply summarize all of these under the broad heading of 'nature mysticism' and thereby suggest a general tendency on the part of the Expressionist artist to entertain feelings of intimate connection, through sensation and intuition, with the unitary whole of nature.[26]

Now, once we assume that the Expressionist artist has a spiritually compelling experience of contact with a natural phenomenon, he will, understandably, expect to seek an appropriate mode of expression to cater for his irrepressible overflow of feeling. Two models of the creative process are available to him, one a neo-romantic model of organic creation, and the other a more up-dated version thereof, abstraction. It seems to me that most Expressionist artists can be situated in terms of their greater or lesser leaning towards one or other of these two models.

Let me first outline the model of organic creation. It is one which dates back to the romantic period and in particular to the teachings of Nature Philosophy and to the scientific theories of Goethe. The latter's ideas concerning the morphology of the physical world provide the crucial impulse for the romantic vision of organicity. Goethe sees nature as a profusion of apparently numberless forms but argues that in fact teeming variety can be reduced by reference to a small number of archetypal patterns. For instance, there are millions of plant species in the world, but, according to Goethe's suggestion, only one fundamental morphological principle. Identifying this in terms of the *leaf*, Goethe speaks of the *Urpflanze* or primal plant as the notional generating form out of which each variant plant species is generated in actuality. Extrapolating from this picture of the world by tracing archetypal patterns in

zoology, anatomy, geology, astronomy and so forth, the poet-scientists of the romantic period, such as Novalis, J. W. Ritter and C. G. Carus, developed a procedure of creative perception whereby the subject looking at a given object (and by 'looking' is meant a warm, empathetic mode of perception, rather than something cool and objective) is able to divine within the particular phenomenon that elemental quality of configuration which betrays its archetypal origin. Any single plant is then seen to display itself as representative of all plants, any one landscape becomes an emblem of all landscapes. Indeed, pressing their analogical vision even further, the romantics insist that the single phenomenon is a microcosmic repository of the network of sympathetic relations which governs the entirety of nature. That is, the complete system of harmoniously regulated forms is accessible through any one example.

Artists of the Expressionist period seem still to favour this romantic cast of thought. Ernst Barlach echoes the romantic view quite literally when he remarks that 'for me the organic in nature is the expression of its inner being',[27] if we assume that by 'inner being' is meant some essence to which the artist gains access through the empathetic recognition of natural structure. Emil Nolde formulates his ambitions as a painter in terms of an instinctive participation in the processes of nature, such that when he selects certain colours for certain shapes, he is operating 'as consequentially as Nature when she creates her own forms, like minerals and crystallizations taking shape, like moss and algae growing, like the flower which unfolds and blossoms beneath the rays of the sun'.[28] Organic creation means aligning one's private impulses with those of nature, reaching in Klee's phrase 'deep down to the source of All', so as to draw upon elemental energies which then translate themselves through spontaneous gesture, mediated by instinct and intuition rather than intellect, and finally arrive at the surface of the painting in the form of brush-strokes perfectly attuned to natural pulsations.

I would suggest that this model of artistic creation is no more than the one I established earlier – the expressive subject spontaneously externalizing impulses from deep within – with the new twist that those impulses are now defined not as the expressions of an idiosyncratic temperament, but as universal ones which reach back mysteriously to a deeper, shared ground of experience. This deeper process might even be formulated as 'Nature expressing herself through the sympathetic sensibility of the artist'.

The organic model can, I believe, only be understood as a poetic myth, though this is not to deny its potency. Certainly in the romantic period, as evinced in the work of Caspar David Friedrich, it carried ennobling overtones consonant with the romantic ideology of the spiritually regenerative potential of landscape art. As a myth, however, it is hard to pin its presence down in the actual practice of artists in the modern period. A few examples will establish this difficulty and lead to an inference which will help me pinpoint the nature of Expressionist creativity more exactly.

In principle, the medium of the dance might be taken as the one most readily reconciled with the organic principle. After all, dance means expression in three dimensions, using a living and mobile body, something literally part of natural creation. When, according to the principles of a Duncan or a Wigman, an impulse from deep within the dancer gives rise to a physical movement, then the dancer's body becomes the indexical sign of a natural meaning, its organic incarnation. Nolde's image of the blossoming flower comes to mind: the image of the unfolding of petals as the plant achieves fullness of being is one which perfectly echoes the Goethian ideal at the same time as it reminds us of one of the most compelling gestures in dance, the upwards transmission of muscular impetus, the body stretching and arms being raised like petals to the sun.

Shifting my focus to architecture, I would cite once more the two major examples of Expressionist architecture, Men-

delssohn's Einstein Tower and Poelzig's Grosses Schaus-
pielhaus. Each may be said to embody shapes found in the
organic world – the swirl of a soft substance like whipped
cream, the jagged bristling of stalactites. I referred earlier to
Finsterlin's unrealized blueprints for structures which
appear to sprout out of the ground like fungi or squat
plants. Again these could be seen as instances of organic
creation in that the architect diverts his design away from
angles and straight edges and thereby upholds an affinity
with nature rather than technology.[29]

Although it might seem that three-dimensional media
lend themselves more convincingly to the organic model, I
find that Expressionist sculpture provides little support for
my thesis. Ernst Barlach may once have affirmed an
allegiance to the organic model (in a letter which criticizes
Kandinsky's abstractive model, to which I shall return in a
moment), but I cannot say that he produced any actual
carved object which might be unequivocally categorized as
'organic'. His human figures, strained and distorted in their
attitudes, do at times embody ecstasy – but their character
is more geometric than organic (and, I might add, more
expressive of individual anxiety than of transpersonal har-
mony). Since other efforts in the field of so-called Expres-
sionist sculpture are restricted to the mimicry of cubist and
futurist configurations, I am compelled to call upon a non-
Expressionist, Hans Arp,[30] as my example of an organic
creator. His flowing biomorphic carvings in white marble,
often left out in the open air like natural objects, fulfil the
romantic ambition of attuning human creativity to natural
process.

How might the organic model manifest itself in the two-
dimensional medium of painting? I argued earlier that if an
indexical relationship is posited between the artist and his
brush-stroke, this might facilitate an act of 'organic crea-
tion' once nature became the stimulus of the expressive act.
But doesn't such a description begin to sound far-fetched?
What examples can I cite of such an intimate affinity
between painter and natural world? My evidence is again

skimpy, but worth adducing as a prelude to my subsequent discussion of abstraction.

One example of picture-making on an organic basis is the work of Wols. His quasi-abstract pen-drawings depict bristling tendrils, feelers, hairy roots or swollen tubers, which seem to carry echoes of half-remembered aspects of organic growth. The drawings are, so to speak, biomorphically plausible without actually looking like any single plant or marine creature one could pinpoint. In this sense, the artist could be said to be working *along the lines of nature* rather than in strict imitation of nature: it is as though Wols has taken out his personal option on nature's universal patent and can generate at will in an idiom whose relation to the original idiom of natural growth is indexical and intimate rather than iconic and distant.

The early work of Alfred Kubin includes a set of non-figurative paintings (1906). Kubin was later to develop a style of spiky fantasticality which is of less interest to the Expressionist project. But in those early paintings he seems to have evolved an uncannily convincing version of organicity, in a way similar to Wols. Inspired by images of minute organisms viewed under a microscope, Kubin speaks of his enterprise in terms which convey an ecstatic sense of unison with organic life.

I deliberately laid aside every reminiscence of the given organization of nature and used bundles of spires and bracts, fragments resembling crystals or shells, scraps of flesh or skin, leaf ornaments and thousands of other things to form compositions that over and over again, even while I was working, astonished me and filled me with deep satisfaction, made me as happy, in fact, as the act of creation has seldom made me before or since.[31]

Now in each of these two latter examples the avowed project of working in unison with natural laws reflects a principle of organicity perfectly in keeping with romantic ideals. One aspect must however strike us as anomalous – the fact that the pictures do not actually throw up literal reminiscences of the phenomenal world. Of course, it could

be argued that even in the romantic period, the principle of 'organic creation' did not exclude stylization. Friedrich, for example, rarely produced paintings of named sites, but rather landscapes which synthesized perceptions collected across time from different parts of Germany. It follows that his claim to organicity would be centred on notions of spiritual consistency rather than mimetic fidelity. All the same, it might be argued, Friedrich's pictures do still look like landscapes, whereas the images of Wols and Kubin seem to avoid direct reference to natural objects. Their allusions to natural form are illusory, or at best mysteriously indirect. And so I would formulate the issue as follows: how can painters in the Expressionist orbit be said to be loyal to romantic notions of organicity, if their actual practice tends towards the non-figurative?

My answer to this question is simple. It is that, while susceptible to the general attraction of ideas arising out of romantic nature philosophy, the Expressionists were living a century or so later, at a time when romantic ideas had long since been discredited in the field of science. Modern physics in particular had made significant progress and had drawn up a rather different set of principles for understanding the shapes of the material universe. The first two decades of the twentieth century were a time of amazing innovations in the field of atomic research. Planck's quantum theory and the laws of relativity formulated by Einstein were complex and mysterious, which did not make them any less compelling. While varied in their stresses, the physical theories that came into currency rested on the fundamental proposition that mass is a form of energy, rather than an opaque lumpiness: all objects in nature, including the human body, are made up of atomic pulses. Physical reality could therefore be verified only by way of inferences based on the behaviour of recording instruments which were no longer capable, as the microscope had been, of offering visible glimpses of the cellular textures of organisms, but could register only things like impulses, waves and ripples. In the popular sense, the one which would have

most appealed to artists like Kandinsky, reality was being described as made up not of concrete components, however small, but of energies and vibrations.

What I am suggesting is that modern physics was, albeit unwittingly, providing the stimulus for an up-dating of romantic notions of natural process.[32] If things are henceforth made of 'mind-stuff' (in Eddington's robust phrase), the Expressionist might be tempted to infer that attunement to natural process must now mean cultivating a spiritual relationship with the invisible forces which regulate the world. If physics had become a kind of applied metaphysics, then the romantic principle of unison with nature must be understood in terms of adjusting one's intuitions to a sub-atomic reality. Since the scientists were addressing this 'invisible' nature in terms of mathematics, the artist would need to adjust his idiom accordingly. A fundamental shift thus occurs in the nature of the painted sign. No longer was it enough to record the direct imprint of a visible form derived from nature. It was necessary for art to develop the equivalent of the symbolic code of mathematics in order to transcribe intuitions of organicity which had now become invisible.

So it is that, in this final stage of an evolution dating back to the romantics, we arrive at a model of symbolic transcription which will be the most advanced version of the Expressionist model of organic creation. *Abstraction*, then, is the idiom seen to be most appropriate for the registering of intuitions of ripples and vibrations which are the 'content' of the new reality. Thus it is that, in this sphere at least, Expressionism shifts from an indexical to a *symbolic* emphasis. For the abstract manner as pioneered by Kandinsky, Morgner and others rests on the premise of a code of equivalences (as it happens, largely dependent on colour values) which have a purely symbolic, i.e., non-existential link with what they represent. Nature is thus transliterated into new dimensions: her visible aspects are set aside, and her invisible relationships transcribed on to canvas in terms of symbolic gestures.

I have travelled at some speed through this argument concerned with the trend to abstraction in the Expressionist period. Of course, not all Expressionist painters went all the way with Kandinsky and his immediate associates; many preferred to hold on to some sort of token recollection of a familiar, visible reality in their work. Kirchner, interestingly, is capable of expressing in the same statement an extreme 'modernist' distaste for mimesis – emphasized to the point of sounding like an out-and-out manifesto for the non-figurative style – alongside the guilty admission (disguised as a concession to his public!) that he still likes to keep some element of referentiality in his paintings. 'It's not right to judge my pictures according to the criterion of fidelity to nature, for they are not replicas of specific things or entities, but autonomous organisms made up of lines, surfaces and colours which only contain natural forms to the extent that these are necessary as a key to comprehension.'[33]

And, along with Kirchner, there are many examples of artists who indulged in a *relative* abstractionism, in the sense that they practised distortion and caricature on their subject-matter, while holding back from the final leap into the non-figurative. Thus Macke, despite his admiration for the work of Robert Delaunay, who had (by 1912) decisively pointed the way to non-figurative form, still hesitated on the edge, producing stylized yet still recognizably figurative paintings of people strolling in parks. Franz Marc continued to insert undeniable references to animals and landscapes in his last paintings, even though his aesthetic credo, as formulated in letters and printed texts, contained as its nucleus a tacit commitment to taking the eventual step into abstraction.

It is worth citing one of these texts by Marc in final clarification of the distinctive position which Expressionism assumed in respect of impressionism and naturalism. Despite the non-figurative drift of post-impressionism (Gauguin, Cézanne) and cubism (Braque, Picasso), these were targets which remained, as late as 1914, of strategic import-

ance in the clarification of where a genuinely Expressionist territory started. The following expressions of dissatisfaction with surface appearances and of concern for deeper levels of reality are all part of a young Expressionist's typical fighting-talk in the avant-garde battle.

Why should we artists not seek out metamorphic forms? Why should we not seek out things as they really are, behind appearances? – Have we not learnt the centuries-old lesson that things speak to us less and less, the more we hold up to them the optical mirror of their appearance? Appearances are eternally flat, – so push them away, right away, pull them clean out of your mind – think yourselves away, throw out your images of the world – and the world will remain behind in its true form, one which artists can intuitively perceive. A demon allows us to peep through the cracks in the world's surface and, in our dreams, leads us behind the world's bright backdrop.[34]

Such verbal images – stepping behind the scenes, probing beneath the surface, tearing the veil from the face of nature – are essentially reminiscences of romanticism. Novalis's formula for the effect of poetic vision had been that 'the world becomes transparent'. Marc will proudly re-affirm the same principle when he writes: 'I am beginning more and more to see behind, or, to put it better, *through* things.'[35] This notion of the transparency of artistic vision is perhaps the strongest link between romanticism and Expressionism. It finds its emblem in the image of the crystal, beloved of Novalis, who saw in it the perfect embodiment of the ideals of organicity and revelation, and celebrated anew in the work of Marc, Lyonel Feininger and Taut, each enamoured of the spiritual effect of refracted beams of light, and the metaphoric resonances of a transparent object through which light can pass – the crystal seen as token of a luminous reality lying below opaque surfaces.

Thus does Expressionist art assert its metaphysical vocation, presenting itself as a practice regulated not by physical conditions but by intuitive perceptions of the non-material. Kandinsky's lyrical terms like 'inner seeing', 'vibrations' or the 'inner sound' of an object are the faulty utterances of a

thinker who saw the truth of the matter as lying some way beyond the orbit of ordinary perception and speech.

What Kandinsky above all was aiming to achieve was some form of empathetic coincidence of the individual mind and the universal spirit pulsating through all things. His compositions, which from around 1910 grow more and more independent of worldly appearances, are conceived as symbolic articulations of spiritual truths which are inaccessible to casual vision. Kandinsky's conception of a valid abstract composition may be negatively defined from two sides. It is on the one hand emphatically *not* something which submits to the visible surface of the world: objects are now 'transparent', that is, to be perceived in terms of their invisible value. On the other hand, the work is not a purely formal construct, created without reference to any reality outside the picture-frame. Kandinsky was adamant on this point, insisting that an abstract art which ignores the spiritual dimension will turn into 'mere geometric decoration resembling something like a necktie or a carpet'.[36] By contrast, he conceives of non-figurative painting as being produced by 'inner necessity, which springs from the soul'.[37] That is, the abstract image must be directly linked

to a reality of essential meanings, with which the artist is intuitively and emotionally engaged.

In this sense, the Expressionist model of abstraction diverges fundamentally from that current in modern non-figurative painting which accepts internal aesthetic relations as a sufficient basis for composition, in the way that, say, Colour Field painting has done. But, as I have argued from the outset, Expressionism could never move in the direction of art for art's sake. Its reiteration of the values of vitality and spontaneity, its dynamic sense of contact with felt experience, mean that, even when it embraces a theory of abstraction, it does so not in terms of cool speculation but as an emotionally charged project. Far from abandoning real feelings, the Expressionist abstractionist trembles with concern for them. The practice of abstraction is, for him, not a suppression of the world of encounters and responses, but an *abstraction of its essence*. And this contact with essence is not an intellectual but an intensely moving experience – it should remain so in the act of expression which transmits feelings to others.

It is worthwhile situating these positions with respect to a book about abstraction which became an intellectual best-seller during the Expressionist period. I am referring to Wilhelm Worringer's *Abstraction and Empathy* (*Abstraktion und Einfühlung*, 1908), in which – in a typical argument based on antithesis – the author separates out two contrary practices which artists have followed throughout the history of art. One is what Worringer dubs the 'organic' or naturalistic style, which is grounded in perceptions of the phenomenal world and reflects a desire to depict objects without distortion. Such a mimetic style, Worringer argues, arises in cultures whose relationship to the world is empathetic and harmonious. The opposite tendency is the abstract style, which expresses itself in geometric, non-organic shapes which deny any affinity for nature. Such a style is indicative of a stressful, anxious psyche, a sensibility fearful of its contacts with reality. Such a style could readily be equated with contemporary Expressionism in its frenzied quest for

principles of pattern within a world of collapsing spiritual and psychological certainties.

Much has been made of Worringer's ideas, which at certain points do offer acute insights into the compulsions of the age. The accent on anxiety and on crystalline form as being typically the motive force and the creative manner of Expressionist work does touch upon certain truths. But I would contend that Expressionist abstraction, as defined in Blue Rider circles at the very least, does not have this negative character of life-denying geometry about it. Distortion there was in Expressionism – the Bridge artists, for example, pursued a very rigorous programme of object-deformation. It is equally true that angular geometric shapes are part of the Expressionist pictorial vocabulary (and were developed by the later Kandinsky into a characteristically 'measured' idiom). Moreover, crystalline symmetry was an ideal for painters like Marc and Feininger. But do these abstractive features necessarily reflect states of anxiety and stress, as Worringer seems to suggest? I would hold that the Expressionist move to distortion and thence to abstraction is a *reaction* to anxiety, not a literal expression thereof. Rather than representing a *symptom* of a spiritual malady, abstraction should be seen as its 'cure', the *solution* to the problem, whereby things which seem superficially disorientating are shown to be amenable to a more penetrating vision. Thus, where Worringer sees the production of inorganic forms as a sign of a reality-crisis and associates this with what he calls the 'Gothic' or Germanic tendency towards disharmony, I would argue that Kandinsky and his associates offer a spiritual synthesis whereby reality *more deeply understood* becomes the basis for a sense of unity and 'belonging'. (The synthesis rests indeed on what could well be called 'empathy', thus reversing Worringer's contention that Expressionism equals unalleviated angst or alienation.)[38]

So it was that the 'Savages of Germany', as Marc dubbed them in one of the leading manifestos of the Blue Rider Almanac, came to recognize that 'art was concerned with

93

the deepest things, that a true revival could not be a matter of form but had to be a spiritual rebirth'.[39] I see the fervent ambition to bring about this awakening as one of the most forceful themes in the Expressionist programme. That historical circumstance, and the rise of National Socialism in particular, were antagonistic to the implementation of such dreams on a collective scale, does not diminish their utopian resonance, their potency as gestures towards a Something which vibrates even if 'unsuspected and ignored by all'. Or, as Ernst Bloch was to argue in such works as *Spirit of Utopia* (*Geist der Utopie*, 1918), the category of the 'not-yet' is not an index of sterile idealism, but of 'being-as-hope', a dynamic mode of consciousness which, dramatically focused on the potential shape of an imagined future, functions as a creative ferment within the individual, sustaining his effort to transcend the present world of capitalist surfaces and to make real the premonition of something like a terrestrial paradise.

IV
STYLE AND
RESPONSE

As I promised at the outset, this has not been an even account of Expressionism. I began by exploring the premise that the creative individual should seek to expose his sensibility in his artistic gestures and thus leave an existential mark upon his work. I went on to propose a notional development whereby the self-engrossed individual begins to scan the world around him and to bear witness to external impulses, whether these announce catastrophe or harmony. I spoke of the foregrounding of physical and spiritual vulnerability, and of the Expressionist association of a neo-romantic spirituality with the modern idiom of abstraction. I located the compulsions of the Expressionist rebellion in a disgust with contemporary social and cultural systems, and pointed to a tendency to elaborate visions of a mystical or utopian cast.

Seen in cool intellectual terms, the multiple aspects of Expressionism might seem discrepant, even frankly contradictory. However, as I hope will have become clear by now, the point is not to reduce Expressionism to a series of concepts, but to recognize the deeply emotional context in which those concepts are situated. What emerges as the common denominator among Expressionist artists and thinkers is an instinctive loyalty to inner certainty, coupled with the sense of needing to give swift expression to that certainty. It is in this respect that the movement finds its cohesion, in an unswerving commitment to immediacy and to unconstrained contact with an audience. I spoke earlier of the Expressionist as one who tends to speak to us with his hand on our shoulder: at times we might want to adjust the

95

image and say that he sometimes seems to want to whisper into our ear, or occasionally to shout at us while gripping us by the throat! Despite these variants in the tonality of the expression, there remains the constant of urgency, and the implied demand that we, as audience, should respond unhesitatingly and without sham. Now that I have outlined the general nature of the Expressionist project, I want in this chapter to survey some of those strategies of expression – evinced in devices and stylistic mannerisms – which typify the Expressionist manner across a variety of media. In thus defining a notional 'Expressionist style', I want particularly to attend to the response which it seems to presuppose in the audience to which it is addressed.

An impression of intensity and concentrated energy is, I have suggested, a hallmark of Expressionist works. In the theatre, heavily stressed gestures became a noticeable component of an Expressionist acting style. In his essay 'The Man of Soul and the Man of Psychology' ('Der beseelte und der psychologische Mensch', 1918), Paul Kornfeld calls for a break with the fussy characterization of naturalistic drama, and for bold emphases in diction and gesture so as to transcend mere naturalness. The Expressionist actor was encouraged to disclose emotion at its highest pitch, making use of his script not as the description of an emotion which he was asked to 'read off', but as a stimulus to seek within his own emotional resources some fund of feeling which would articulate itself in powerful performative gestures that, in principle, might leave the text behind. A style of exaggerated postures and gestures soon evolved in which normal movement was displaced by a stylized repertoire of emphatic signals. A certain slowness entered into the actor's motions, and even a hesitation between cues; so that the spectator might find himself called into a condition of suspended expectancy, propelling his own body, in imagination, into the deferred fulfilment of a given gesture. Of course, the live performances of the Expressionist stage are no longer available for us to evaluate, yet we can still look at

films of the period and see something of what such acting looked like. In *The Cabinet of Dr Caligari*, the murderous zombie Cesare played by Conrad Veidt moves with slowed-down deliberateness and hypnotic poise about the fantastical set, his slender body in its tight black costume representing a kind of cipher of diabolical unnaturalness. In *Warning Shadows* (*Schatten*, 1923), the face of the jealous husband played by Fritz Kortner is caught in weirdly lit close-ups, eyeballs rolling and clenched fists raised in spasms of scarcely restrained violence made physically visible in the trembling of taut muscles. An emphatic, melodramatic style is of course a material consequence of the lack of a soundtrack, and the Expressionist acting style is not really so different in kind from that of non-Expressionist styles in the silent cinema. None the less, the convulsive equation of body and soul, and the use of angular gestures held for long moments which seem to implicate every fibre of the actor's body, these are procedures of amplification which become specifically 'Expressionist' to the extent that they bear down upon the very limits of the spectator's tolerance.

As a general rule, emphasis without restraint conduces to a stylistic consistency pitched at the highest level of amplitude. Pictures by artists like van Gogh, Kokoschka, Jawlensky and Soutine have a super-charged density of gestural energy, such that every square centimetre of canvas seems packed with equally insistent vibrations. An organized structure can, at the limit, collapse and expose a texture without nuance, evenly intense in all its parts. This particular implication of Expressionist practice was realized in the work of abstract Expressionists like Jackson Pollock, whose canvases end up with no centre and no priorities: they are sheer energy, packed in from edge to edge.

Dense uniformity seems more tolerable in the visual arts than in poetry. Once writers transmit their message in like fashion, refusing to tone down any part of their text and sustaining a noisy rhythmical stress across every line, the

effect is soon unbearable. Johannes R. Becher will carry on in the following fashion for some 120 lines in the poem 'Man, stand up straight!' ('Mensch stehe auf!'):

> Man: you humanity-denying solitary fumbler, sinner
> sentinel brother: who are you!
> Turn in your grave! Spread yourself! Start yearning!
> Breathe! Decide at last! Turn around! . . .
> Storms of sulphur plug up that vicious azure space.
> The horizon of your longings is all railed off.
> (. . . down into your blood! Chest up! Head off!
> Ripped off!
> Splattered. In the snout of the sewers . . .)
> It's still, it's still time!
> For us to meet! For us to get going! For us to march!
> For stepping flying leaping out of the Canaanite night!
> It's still time –
> Man Man Man stand up straight stand up straight!!![1]

Hyperbole and bombast are the obvious dangers of an aesthetic principle of unalleviated high tension. Theodor Däubler will coin the inflated image of 'millions of nightingales singing', while Wilhelm Klemm will strain a simile to the point of grotesqueness: 'My heart is as large as Germany and France put together.'[2] Alfred Wolfenstein depicts the declamatory mouth of the poet in wildly exaggerated terms:

> As the cloud passes through in flames, as the cloud
> passes through like thunder between head and
> earth
> A man's speaking mouth convulses.
> Lightning teeth mow down
> Whole thickets: and flowers sprout up at once, airy
> and bright.[3]

Such a fixation on extremes leads to negligence in the area of nuance, which eventually means that the reader ends up in a state of numbness. To be solicited at every line or point in a work is a tiresome thing: as listener or spectator, one cannot *keep on* being freshly moved by a performance which goes on insisting that its every moment is stirring. The

superior Expressionist works are those which strive for the illusion of a scale of expansion such that one moment of excess appears to be capped by the next: the type of such development through time is the crescendo effect, not possible in a static medium like painting, but feasible in media like dance or music.

Sheer vastness can itself become a value for the Expressionist. Simple ambitiousness of scale is a feature of many Expressionist careers: Munch, for instance, worked for decades on a series of paintings entitled *The Frieze of Life*, which would group many of his most famous pieces. (Since he sold off canvases as he went along, he had to re-paint fresh versions to keep the series complete.) Munch's work is generally characterized by the large format – he had an open-air studio to cater for unusually large canvases – and one of his major commissions was a huge set of murals for the Great Hall at Oslo University. Kokoschka's city panoramas are also immense canvases, with a bird's-eye viewpoint on to a yawning space that teems with splashes of paint, to create an effect of detail packed into immensity. In the sphere of architecture, one could say that the meaning of Poelzig's Grosses Schauspielhaus is inseparable from the impact of its gigantic size.

A favourite effect of set designers in Expressionist productions was to use a curved skyline on an empty stage with lighting suggestive of a heath or a desert by night: the emphasis on infinite space and emptiness provides a context for the harrowing contemplation of the single individual on stage, who can see no direction in which he can move that will decrease his isolation. Lighting effects were often used, both on stage and in film, to create eerie presentations of space as something boundless and inhuman.

At the other end of the scale, effects of compression, of space closing in, were exploited in a similarly pronounced way. The underground cavern in *Metropolis* closes menacingly over the heads of the rebellious workers. Such scenes in which crowds are pressed together in confined spaces provide a valid theatrical metaphor for social repression or

degradation. In the 'Ivan the Terrible' episode of Paul Leni's film *Waxworks* (1924), the tyrant's palace is portrayed as a repressive space of narrow corridors, steep stairwells and low doorways. The topography of Kafka's novel *The Trial* is an unsettled mixture of confined and open spaces. When K visits the mighty cathedral, he can scarcely see across its echoing spaces; one day at the office, he chances on a tiny room no bigger than a cupboard in which two men are busy whipping someone. Kafka seems to project states of intense anxiety into these exaggerated settings, portraying angst as an experience of extremes – presenting, on the one hand, the subject's anguish at being alone in a featureless universe, and, on the other, his panic at being imprisoned for ever in the insulated cell of consciousness.

The Expressionist treatment of the city tends to play variations on these basic associations of claustrophobia and agoraphobia. The narrow streets and alleys of a real medieval town on the Baltic coast become, in Murnau's *Nosferatu*, the very locus of the uncanny. More heavily emphatic were the sets painted for *The Cabinet of Dr Caligari*, where characters are pressed into oddly tight corners or sent up widening alleys in a maze of disturbed angles and conflicting planes which exactly complement the film's themes of dislocation and giddiness. Karl Grune's *The Street* (*Die Strasse*, 1923), with sets by Ludwig Meidner, presents a space of temptations and menaces, with its lurid pools of gas lighting, shadowy doorways and uninviting stairwells. The association of streets with menace evolved speedily in the Expressionist period to produce a staple set which was to become an indispensable feature of Hollywood *film noir* – the stereotype includes asphalt glistening in the rain, anonymous traffic, prostitutes hovering in the bright circle cast by a street-lamp, swirling fogs and shadows out of which strangers may step at any moment. The interplay of confinement and exposure is exploited in such settings to promote a generalized view of the city as a place of intensified experience, and especially of fear (most ob-

viously signalled in the many films dealing with the subject of a nameless mass-murderer on the loose). The street thereby becomes a stereotypical objective correlative of the troubled psyche of a generation.

City streets crop up incessantly in other media. One of Munch's early exercises in the depiction of angst, the demurely titled *Spring Evening on the Karl Johan* (1892), shows bourgeois men and women, smartly dressed but with faces as pale and emaciated as those of concentration-camp victims, promenading along the pavement. Early passages in Rainer Maria Rilke's novel *Malte Laurids Brigge* (1910) – a book by a non-Expressionist which nevertheless accurately catches the Expressionist note in this instance – concern a lonely man dragging his feet through the streets of Paris and seeing passing beggars and the lame in conjunction with the peeling wallpaper of half-demolished houses as symbols of metaphysical trauma. Heym's Berlin and Kafka's Prague are the natural habitat of oppressive, undefined forces which prey on individuals and create a gloom-ridden mood of decay and hopelessness. Nolde's early paintings of Hamburg and Alfred Döblin's novel *Berlin Alexanderplatz* (1929) place a slightly more naturalistic emphasis on the sleaziness and corruption of the city, though the trend to a glaring, nightmarish style orientates such works towards an Expressionist effect.

The by now familiar penchant for the excessive, the flamboyant, leads certain Expressionists to adopt a more positive, sometimes ecstatic attitude towards the metropolis. Kokoschka's evocations of European capitals (Vienna, Berlin, London, Amsterdam, etc.) offer a giddy aerial perspective and encourage sensations of exhilarating weightlessness. The theme of apocalypse, of the city being destroyed like Gomorrah, is a seductive fantasy in the cityscapes of Ludwig Meidner, who even penned an essay entitled 'An Introduction to Painting Big Cities' (1914), which recommends ambiguous foreshortening, dark, chaotic masses, short straight lines bristling in all directions, and a brutal sharpness about the picture's focal centre, often the

view up a street, rising. 'There isn't much that has to be said about colour,' writes Meidner. 'Take all the colours of the palette – but when you paint Berlin use only white and black, a little ultramarine and ochre, and a lot of umber.'[4]

Under the partial influence of futurism, some Expressionists invested enthusiastically in the imagery of *speed*, producing lyrical travel sketches about being swept along in aeroplanes, cars or trains and, more often than not, climaxing in a breathless ecstasy in which separate moments in time and separate points in space seem to be suddenly fused within a single giddy consciousness. Stadler's poem about crossing a railway viaduct by night has been quoted above. Benn's 'Express Train' ('D-Zug') ends with a vision of primitive life in an exotic tropical environment. One of Heym's many poems entitled 'Berlin' traces the arrival of an express in the metropolis ('The train arrived. We thundered in beneath the roof / Of the station, which was full of the bluster / Of evening in the metropolis, noise and the floods of humanity')[5] and announces the abrupt cutting and jerky pace of a film like *Berlin – Symphony of a Metropolis* (*Berlin, die Symphonie der Grossstadt*, 1927) by Walther Ruttmann. (Though Ruttmann is usually seen as a proponent of abstract cinema, the theme and mood of this film certainly evoke an Expressionist vision.)

City themes may be seen as the echo of an aesthetics of shock which can be traced back to Baudelaire and his impressions of a decaying Paris. They are taken up with such enthusiasm not so much because Expressionism is particularly at ease with such themes – there is evidence that non-urban settings provide a more natural frame for the expression of unconstrained feeling – as because the city is the elective site of urgency. With its ambiguities and excesses, its capacity to exacerbate a craving for naturalness while creating a seductive artificiality, the city outraged and hypnotized a good many artists. Kirchner's obsession with the cocottes of the Kurfürstendamm epitomizes this contrariness – emotions of attraction and repulsion seem to be twinned in these canvases, where skinny women splashed

with garish colours and defined in black, stabbing strokes attain a paradoxical elegance, nerviness and sultriness dissonantly combined.

I'd like to move on from these thematic remarks to consider some of the typical features of the Expressionist painting style which determine the way things are presented as visible forms. Sharpness and starkness are clearly the strongest characteristics. Bold and rigid verticals are common, with foreground figures often pinned against the skyline, as in many of Munch's most haunting images. In the paintings of Heckel, the human figure is defined by sharp lines that switch direction abruptly in ways which reveal a concern less with tracing the outline of the figure than with tracing the gestures of the artist's own body. Schiele's typical spiky lines seem to want to cut the figure out from its background, where it lies seized in a muscular convulsion, indicative of some unpleasant emotional state. A good many Expressionists tend to paint over the outline of their figures again and again, in almost compulsive gestures of emphasis. In several late paintings, van Gogh blacks in the edges of his figures, while Munch dips into his reddest pots to add extra contours to such pictures as *The Dance of Life* (1900), so that each dancing figure, man or woman, is rimmed round with thick vermilion ribbons suggestive of life-energies being frustratingly expended. Perhaps the most extreme cases of emphatic black outline are those of Rouault, whose portraits resemble clumsily leaded stained-glass windows; and Jawlensky, who paints faces and mountains alike in the simplest strokes and adds band upon band of varied colour to produce rainbow contours that declare the painter's intention to transmit feeling rather than observation, as though he were saying 'each time I run my brush along this same outline, I am not drawing attention to the object depicted but to the emotional intensity whence the creative gesture springs'. Of some Baltic landscapes he did in the summer of 1911, Jawlensky commented: 'The forms were very emphatically contoured in Prussian blue, and emerged irresistibly from an inner ecstasy.'[6]

The aesthetic primitivism of the Bridge group found its natural medium in the woodcut, all but neglected in Germany since the Middle Ages. Artists like Kirchner, Heckel, Schmidt-Rottluff and Nolde eagerly engaged with a technique in which sheer physical excitement – gouging wood with a sharp blade may be readily understood as a channelling of aggressive impulses – merges smoothly into the spiritual or aesthetic excitement at the moment when the imprinted sheet is peeled off the block. A creative collaboration of principles of harshness and softness – the

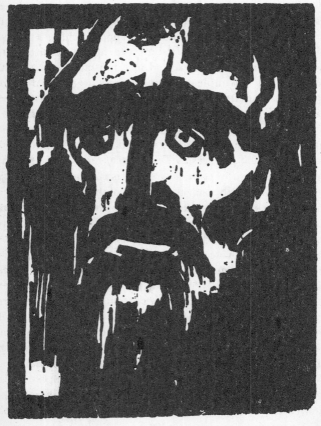

quasi-violent cutting of the block, the tender distribution of inks – is reflected in the contrastive extremism of the woodcut itself. The implacable black of Nolde's *The Prophet* (*Prophet*, 1912) corresponds to the flat surface of the block: the haggard face is constituted of slivers of virgin paper corresponding to the scrambled incisions of the knife. In such works as this, the inherent starkness of the medium seems to be foregrounded as an integral part of the statement: *The Prophet* is not just an image of a face but the record of a process of expression through frenzied marks. The indexical link between visual surface and the artist's presence, imprinted through gestures whose trace is inescapable, lends further support for my model of existential immediacy. 'This is someone appealing to you!' the image seems to cry. To this may be added the further dimension of cultural connotation, since the idea of a face defined by incisions can throw up associations of torture and disfigurement. (It would not be hard to see Nolde's image as belonging in the medieval tradition of depictions of martyred saints.)

Stark contrasts within the limited register of black and white are, of course, to be found in the medium of film. Again, there is the possibility that stylistic features of Expressionist cinema may turn out to be features of contemporary cinema at large, since to exploit the formal potential of the medium was the aim of most early directors of calibre. All the same, and despite striking examples of similar effects produced by non-Expressionists, it is worth listing a few instances of the Expressionist tendency to exploit the expressive force of black-and-white contrasts. To use the word 'chiaroscuro' here seems a little tentative when one is referring to the harsh accentuation and isolation of a face in blinding whiteness, against a background of featureless black shadow. Theatrical experiments in lighting pioneered by Max Reinhardt (not an Expressionist) had been taken over for the Expressionist stage, where they tended to be used not only to accentuate the meaning of events, but to startle the spectator out of any possibility of

relaxation. Single actors or sections of the stage could be illuminated in brief flashes, then plunged into blackness; in Sorge's *The Beggar* (*Der Bettler*, 1912), raking searchlights were allegedly used for the first time. Such experiments were promptly adapted to cinema, where many directors and actors in fact arrived fresh from theatrical productions. While camera movement evolved only gradually, relatively static shots were enlivened by the punctuation of zones of darkness by brilliant spotlights which could illuminate a face, a hand, a tell-tale detail. A gaze surround was sometimes placed on the camera lens to provide ready-made shadow around the edges of the screen and thus frame whatever object or figure occupied the centre of a long shot.

The fantastical appearance of people's shadows becomes an overt theme in Robison's *Warning Shadows* (1923), sub-titled 'A Nocturnal Hallucination', where the narrative is introduced by a music-hall illusionist who projects images on to a screen by moving his hands in front of a candle. A tale of jealousy then unfolds during which shadow effects are adeptly exploited as incidents in the narrative. Thus, the jealous husband is witness to the unthinkable embrac-ing of his wife by one of the guests at his dinner-party. As we are shown by Robison, there is no actual contact, the embrace which sends the husband into such torment being merely an illusion created by the coincidence of shadows thrown separately against a curtain.

The menacing aspect of the human figure when seen as a featureless shadow, like a black silhouette upon a white ground, was exploited in several Expressionist films, before becoming a cliché of today's horror movies. In *Nosferatu* (1922), powerful lighting throws on the wall the shadow of the vampire with its long fingernails, moving purposefully upstairs – the horrible made more horrible by being rendered in this flat, disembodied form. In Henrik Galeen's *The Student of Prague* (*Der Student von Prag*, 1926), two lovers meet on a low terrace by night; their meeting is witnessed by the evil Scapinelli, whose gigantic shadow is thrown up against the stone wall from the garden below, like that of

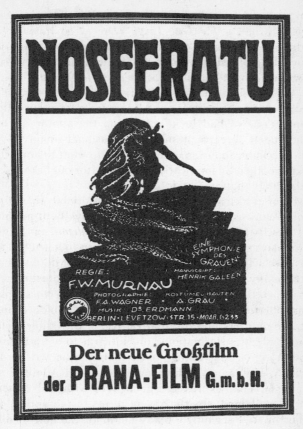

some predatory monster. When Cesare knifes a student in *The Cabinet of Dr Caligari*, the murder is presented in silhouette, the shadow-play exactly equating to a mobile version of the Expressionist woodcut.

Another form of visual play is the use of mirrors, which can be manipulated to emphasize the theme of illusion, as when, in another scene from *Warning Shadows*, the husband discovers his wife embracing her lover as a reflection in a mirror. Mirrors may also function as a means to duplicate and thus to accentuate an image, as when Hutter, in *Nosferatu*, examines his throat in a mirror and finds on it the

vampire's mark – which the spectator therefore sees twice over. Murnau's *The Last Laugh* (*Der letzte Mann*, 1924) contains a sequence in which hideously guffawing faces are shown in deforming mirrors to create a nightmarish impression. In both *Warning Shadows* and *The Student of Prague*, the protagonist smashes a mirror in a fit of rage or frustration. The gesture, quite apart from its superstitious connotations of bad luck, represents the apotheosis of a technique of foregrounding the obsessional image. If the hero of a film can act so excessively as to want to annihilate an image, then by implication the spectator ought to be just as thrillingly haunted by it.

Mirror tricks are akin to the use of double roles for a single actor, as when Werner Krauss plays both madman and psychiatrist in *The Cabinet of Dr Caligari*, or Brigitte Helm plays two identical Marias in *Metropolis*, one good and the other evil. The motif of the *doppelgänger* or double is one of the many devices of nineteenth-century fantastic literature which the more popular Expressionist directors took as their inheritance. Tales of vampires and doubles, of inexplicable murders and disappearances, of incredible coincidences and transformations, are integral to a tradition of short-story writing dating back to romantic writers like E. T. A. Hoffmann, Achim von Arnim and Adalbert von Chamisso. That Expressionism engaged with such material can be explained superficially in terms of the appeal of a subject-matter seemingly ready-made for the new medium of cinema, in which trick photography could make a clay statue come alive, as in Paul Wegener's *The Golem* (*Der Golem*, 1920), or a clip of negative film could transform a wooded landscape into something white and monstrous, as in Murnau's *Nosferatu*. The whole art of the fantastic has to do with seducing the audience into a posture of suspended disbelief, such that paranormal events are, temporarily, accorded the status of reality. In terms of entertainment, this means that an audience may enjoy temporary relief from the tensions of everyday life; but, at a deeper level, the presentation of treacherous transformations, the manipula-

tion of belief, the imparting of an aura of the un̲
normal appearances, may be said to reflect a mor̲ ̲ ̲ous
Expressionist attempt to induce anxiety and vertigo and, by
extension, to point up the shortcomings of orthodox percep-
tion.

Are there similar devices and strategies operating in the
sphere of Expressionist poetry? Once one moves from the
visual to the textual dimension, one shifts from considera-
tions of perceptual impact to ones which tend to be more
cerebral, and are thus *a priori* less likely to be assimilated
from an 'exposed' position. A painting or a theatrical
performance can have instantaneous impact, affecting the
spectator before he is able to withdraw. The reader, on the
other hand, can decide when he will start reading, when he
will stop, how fast he will read and so forth. Given this
factor of 'reader control', the Expressionist poet feels him-
self driven to reach to the very limits of his expressive
resources in order to break through the reader's resistance
and to communicate to him on an emphatic scale. I have
already referred to some of the subject-matter which he will
choose as being attention-grabbing, harrowing, piteous,
exhilarating, and so forth. Since I am now concerned with
exemplifying literary devices, let me briefly offer some
generalizations about the Expressionist poet's *diction* and
use of *imagery*.

'You, poet, don't be ashamed to blow into the ridiculed
tuba. Arrive in a whirlwind. Smash to smithereens those
delicate little clouds of Romantic daydreams, sling the
lightning of the spirit down upon the masses.'[7] This was
Iwan Goll's exhortation to the poet in his bustling, aggres-
sive 'Bugle-call to Art' ('Appell an die Kunst', 1917), where
he foregrounds the virtues of agitation, no-nonsense imme-
diacy and sheer noisiness. If poetry has to make itself heard,
then it must give up any pretension to being polite,
agreeable, pretty, sensitive to ethereal nuance. It must
instead blow the trumpet, bang the drum, make itself heard
– if necessary by summoning up its resources into some-
thing equivalent to a scream. Munch's visual presentation

of this Expressionist extreme is transposed into the poem 'Scream' ('Schrei') by August Stramm:

> Woe space all spaces
> Throttle
> Swing
> And
> Swing to bits
> Swing
> Throttle
> And
> Throttle to bits
> Storm
> Flood
> Swirl
> Squeeze
> Clench
> Woe woe[8]

Such staccato diction – its impact largely attenuated in an English version lacking the vicious sibilance of verbs like *Zerschwingen* and *Zerwürgen* (literally, to swing and to throttle, until something falls into tiny pieces) – is the textual equivalent to physiological phenomena like shivering, or making abrupt and violent movements in which muscular straining and release are maximized. In short, what is being presented, albeit at a distance, is an effect of *intense physical gesture* reminiscent of the Expressionist acting style. The logic is clear: if the Expressionist project consists in transmitting intense impulses from the inner depths of being, and if such impulses are most effectively externalized in the mode of the abrupt, of the unannounced thunderbolt, then an Expressionist poetry will want to exploit aspects of language which lie at the limits of ordinary utterance or even outside those limits. Stramm's 'telegram style' is an extreme result of a principle of wilful linguistic reductionism, in which conjunctions and articles are eradicated, verbs are reduced to the infinitive form, nouns are used in place of verbs, and sentence structure is broken down into laconic fragments of syntax, often breaking grammatical rules of agreement. Stramm even structured some poems as

a vertical strip of one-word lines. One of these, 'Primal Death' ('Urtod'), consists of forty-seven such lines, with a repeated 'refrain' ('Space/Time/Space') interspersed with a cavalcade of rhymed infinitives of verbs of violent action and culminating in the stark monosyllable *Nichts* – nothingness.[9] Words so shorn of the customary wrapping of grammar and context enter the reader's orbit not as statement asking to be grasped or decoded, but as brash, bustling impact – 'expression' in its starkest form, compressed energy bursting forth like a fist.

Other Expressionists, while looking to the same armoury of German plosives and sibilants, made use of very lengthy lines, which roll on at speed with pulsating stresses to create an impression of the throbbing outflow of irrepressible expression. Stadler evolved a loping, almost elegiac line, expressive of ecstatic intuitions emerging into articulacy; Becher developed an apocalyptic style of compound nouns and chattering repetitions suggestive of an overload of impulses, a Babel-like excess of words. The actor Richard Blümner, whose poetry readings had accustomed him to think of poems as physical performances, while very probably alerting him to the need to emphasize volume of sound (noise) rather than message, composed experimental poems made up of pure sounds, which he called 'absolute poetry'. Pieces like 'Ango Laina', with lines like 'Oiai laela oia ssisialu / ensudio tresa sudio mu mischnumi / ja lon stuaz / brorr schjatt',[10] seem to be reaching even beyond the boundaries of the German language in order to tap an effervescent expressivity below the cultural superstructure of vocabulary and syntax.[11]

Many writers, while remaining orthodox in their use of syntax and even verse structure, compel attention in the semantic sphere by their provocative use of imagery. Outlandish metaphor had become an index of modernity since Rimbaud; Expressionism shows itself scarcely less outrageous than surrealism in its search for such startling formulae as Heym's 'the frog's finger of fear' or Else Lasker-Schüler's 'the moon swims softly through my

blood'.[12] Alfred Lichtenstein produced a poetry peppered with incongruous imagery, a kind of irritation of common-sense which produces a strong impression of the Absurd. 'The gas lamps are captured flies', or 'The sky is like a blue jellyfish', or 'The sky is a roll of grey wrapping-paper / On which the sun is glued – a dab of butter'.[13] The quirky humour of these coinages is often a function of a deliberate reversal of poetic clichés of the beautiful. On another plane, the images of Trakl seem to derive from some deeper, more mythical level of the imagination, lurching into focus like troubled figures in a distorting lens, as witness these lines from 'Rest and Silence' ('Ruh und Schweigen'):

> Shepherds buried the sun in the barren forest.
> A fisherman drew the moon
> In a hair-spun net, out of the freezing pond.
>
> In blue crystal
> Lives the pale man, his cheek pressed against the
> stars;
> Or else he droops his head in purple sleep.[14]

The lack of a secure ground against which to situate Trakl's allusions, the strangeness of these simple yet profoundly disjunctive statements, make for an unnerving sense of disorientation. Such texts, conjuring up so many gestures without context and emotive moods without a name, forbid the reader to label them as atmospheric nature poetry. Rather, if nature is at all in Trakl's mind, it is a nature transfigured beyond recognition, a nature estranged from itself and lacking in any secure co-ordinates.

Turning back to painting, I would suggest that this experience of losing our footing, this feeling that strong expressive impulses can actively discourage us from recon-stituting them as a coherent system of meaning, as a message, can be a typical reaction. Expressionist art is, after all, aimed at the transmission of powerful feeling: small wonder that the spectator is thrust off-balance, with no time to exercise intellectual dominion over the affective surge. Convulsions seem to ripple across the surface of Expres-

sionist landscapes such as those of Kokoschka or Soutine, to convey a tacit analogy between the turbulence visible to the eye and an underlying psychological or spiritual turbulence. An impulse to distort the way the world looks is integral to the language of Expressionism, from the rough-edged woodcut figures of a Heckel to the jaunty figurines of a Klee. Caricature seems almost the guiding principle in Kokoschka's portraits, in which sitters find their fingers grossly lengthened and their features crudely botched. The female nude is cobbled together in graceless strips of colour by Schmidt-Rottluff, or stricken in ungainly, lumpy poses by Kirchner, in a manner which prefigures the anti-beautiful approach to painting the female nude which Willem de Kooning and Jean Dubuffet were to pursue in the early 1950s. Kirchner's nudes in particular are almost repulsive in the 'wrongness' of their colours: their bodies are stained with stale pinks and gangrene-like greens, in a manner which suggests not the euphoric rainbow colouring of Fauvism, but a wilful distastefulness that has morbid undertones.

Writing a half-century or more after the event, I can make the basic critical point that shock effects and the sense of *dissonance* should always be measured against the criteria of aesthetic orthodoxy as they alter through time. (There is a secondary, perhaps slighter, variable, that of the divergence in response even between contemporary individuals.) Notions of 'gracelessness' or 'distastefulness' are relative, and it is now open to us, who come after the event, to draw from the paintings of Kirchner and Kokoschka a sense of aesthetic excitement which may prompt us to speak of 'beauty'. What gave meaning *at the time* was of course the context of other paintings, the orthodoxy *against* which these artists were working. Strident colours were the mark of a refusal of impressionist shimmer; ugly nudes a declaration of war on the aesthetic standards of the salon tradition. The same principle applies to the other arts. In poetry, Lichtenstein's ridiculing of traditional poetic properties like the sun and the stars was part of a campaign to put an end to

poetic cliché. And in music, Schönberg's 'emancipation of the dissonance' meant an abandoning of a long tradition of harmonic resolution. To a public habituated to nineteenth-century conventions in music, Expressionist atonality, with its staccato clusters of notes, tended to impose itself as something irritating, even aggressively unpleasant to the ear.

But militant dissonance can be only half the story. Dissent from established forms creates shock; to opt for improvisation instead of planning, for instinct instead of intellect, is to provoke bewilderment, but not to fascinate and beguile. Sheer chaos on its own cannot convert an audience, and cannot therefore sustain a creative relationship between artist and public. And the artist himself cannot survive indefinitely in conditions of discontinuity and formlessness. Before long, the Expressionist rebel finds himself identifying certain principles of regularity which are the spontaneous and often unexpected aesthetic criteria thrown up by his breakaway style. A sense of a new order then begins to emerge. I would like to describe something of what this order might be through a central example, the use of colour in Expressionist painting.

It was the work of the Bridge group to establish colour as the fundamental index of expressivity in the Expressionist work. Inspired (though by no means influenced in all respects) by such predecessors as the late Monet, Gauguin, van Gogh and van Dongen, painters like Nolde, Kirchner and Schmidt-Rottluff advanced speedily towards an idiom of simplified outlines which formed a framework enclosing large areas of bold colour, often applied direct from the tube. Their crucial move was to associate colour not with visible reality (as had been the case with orthodox impress-ionism) but with the artist's affective responses. In this sense, the creative process is based on a schema whereby the initiating sensibility absorbs impressions from the visi-ble world (from a landscape, say, or a nude figure) and then facilitates their return to that world as paint-marks on the canvas. Thanks to this stage of absorption at a deep level of

the sensibility, the painted forms may be viewed as exter-
nalized emotions: colour no longer designates optical facts,
but psychic values. Nolde writes with typical lyricism of his
relation to colour as the raw material of his art, making the
affective equation in a reference to 'vibrating colours like
tinkling silver bells or pealing bronze bells announcing joy,
passion, love, soul, blood, and death'[15].

At once it becomes clear that there cannot be anything
arbitrary in the Expressionist attitude to colour choices.
Arbitrariness is indeed only a transitory stage in the
process, something experienced by those spectators who
might have been expecting a given picture to be realistic (or
at least to respect the more limited colour code of, say, the
pointillist school, where aberrations of colouring seem,
relatively speaking, more capricious than vicious!). For
what now becomes established is a new determination
whereby colour is indexically related to emotion: individual
hues begin to function in a heraldic manner, as a code of
associations begins to emerge out of the consensus of artistic
practice and spectator response. Let us look at two exam-
ples, red and blue.

As an almost universally recognized 'strong' colour, red
has long been culturally over-determined in terms of its
resonances of dynamism, aggression, over-riding feeling. It
could be seen as representing the 'hot' end of the spectrum,
with the blue and violet tones corresponding to the 'cool'
end. When a painter applies crimson, cadmium, scarlet or
vermilion, and especially if he applies them unmixed, he is
inevitably producing visual signals of an emphatic,
not-to-be-missed kind. Red zones or red outlines are imper-
atives to the spectator's eye and consciousness: he can
hardly ignore them and their connotations of violent or
excessive feeling. Given the Expressionist insistence on
flamboyant gesture, it is surely no surprise that their
painting should be dominated by this, the most emphatic of
colours. Examples abound. Munch's *Jealousy* (1895) shows
a woman flirting with a man behind the back of her
husband; her lurid crimson dress is drawn apart to disclose

her body. The glaring colour of the dress, and its insistent framing of naked flesh suggest that Munch is showing us the obsessional image in the husband's mind. The colour red can then be read as a direct reference to his jealousy (cf. the expression 'a scarlet woman'). Pechstein once did a large picture of some red tulips he had seen in a garden in Dresden, a fanfare to pure colour and, by implication, to the principle of uninhibited colour values. Similarly, Nolde paints a still-life of a poppy, which swells to a supernatural size thanks to the incandescence of the dominant colour. The title of this work spells out its true subject: *Great Poppy (Red, Red, Red)* is no longer 'about' a flower, but 'about' a colour. The same sort of point could be made in connection with many paintings of Soutine, such as *Red Gladioli* (1919), or again his *Woman in Red* (1920) or the notorious *Carcass of Beef* (1925). The motif may vary, but the colour keeps the same emotional referent, the same value.

It is perhaps a trap for the critic to attempt to give strict verbal articulation to this value, using terms like 'ecstasy', 'anguish', 'intense desire' and the like. Colours must, in accordance with Expressionist precepts, be allowed to carry their meanings across to us without reference to intellectual, verbal codes. It is perhaps enough that one has a non-intellectual response to Soutine's arresting reds. If one *were* to hazard any comment in words, it might be to point out that Soutine's work at large seems to thrust towards the expression of powerful sensations of an almost visceral kind. He is quintessentially an Expressionist intent on using colour to expose our vulnerability.

What of blue? If red is the colour which epitomizes the dynamic rebellion of the Bridge, then blue may be counted as the emblem of the more introspective or visionary trend signalled in the very name of the Blue Rider circle and its later brief revival in 1924 as the Blue Four (Kandinsky, Feininger, Jawlensky, Klee).[16] A rich, deep blue had been adopted by van Gogh almost as a personal signature embodying feelings of adoration and spiritual euphoria, as in such pictures as *The Church at Auvers* (1890) or his various

paintings of irises. The omnipresence of interrupted, spir-
alling strokes of blue in *The Starry Night* (1889) is an index of
the meaning of blue as the medium of transfiguration or
transcendence. In Heckel's *Glass Day* (1913) or again in
Marc's *The Tower of Blue Horses* (1913), sharper, cooler tones
of blue herald a less agitated but no less fervent transition
from material perception to visions of transparency, of
mystical penetration behind appearances. 'Blue is the male
principle, astringent and spiritual,' Marc once wrote.[17]

These instances of the affective dimension attaching to
colour are intended to make the point that certain basic
associations can at least be hypothesized. If colour has any
impact on a spectator, then it must surely be possible to
posit the general emotional bearing of a dominant colour.
All the same, colour values are operative at the emotional
level, and we cannot be certain that individual associations
will shape up into clear-cut universals. In a section of *On the
Spiritual in Art*, Kandinsky discusses at length the problems
of colour association, and even indulges in some private
associations of a synesthetic type (colours seen in relation to
sounds, as when he suggests that light blue is like the sound
of a flute, a darker blue like that of a cello). However,
Kandinsky quite sensibly makes no claim to universal
authority, and defends the individual's right to diverge from
any provisional agreement of the kind I have been sketch-
ing. Any rigid code of equivalents is thereby ruled out.[18]
Thus, the general conclusion of this discussion is the simple
point that Expressionism eventually sees expressive com-
munication as being tied to the *symbolic resonances* of colour,
such resonances being deemed to correspond to the affective
participation of the painter.

But if colour resonances are to be seen as such a central
asset of the picture, how is the spectator to stand with
regard to the range of impulses he witnesses? What order of
response is in fact 'intended' by the insistent demands of
colour? Jawlensky writes that 'to me, apples, trees, and
human faces are no more than hints as to what else I should
see in them: the life of colour, comprehended by a passionate

lover'.[19] This would suggest that mimesis has been so
thoroughly discredited that painted colours have to do only
with the 'invisible' qualities the artist senses in a given
object, what Kandinsky calls its 'inner sound'. How then
should we position ourselves before a painting by Klee,
produced, as he claims, by an activity of free improvisation
upon 'the colour keyboard of adjacent pots of paint'?[20]

What I described earlier as 'the spiritual impulse,' must
be invoked once more, since it is through an appreciation of

the tenor of the painter's relationship to nature as well as to his palette that I believe an answer can emerge. Let me take an example provided by Franz Marc: the Expressionist artist looking at a chair will no longer be interested in it as an artefact with such and such a position in space, such and such a shape, and so on. Rather he will be aware of those spiritual forces which, so to speak, hover around or behind the perceived object. 'It is not true that the chair stands: it is held. Otherwise it would fly away and unite with the spirit.'[21] It is this invisible quality in the chair which Marc will seek to transcribe – the chair glimpsed in flight, so to speak, rather than the chair on the floor.

As I argued in relation to the question of abstraction, the process of transcription involves an 'abstraction of essence' such that the isolated and even unique object is at last revealed in its universal dimension – a kind of symbol of itself at the same time as it is an emblem of the creative process at large, seen as an operation of transubstantiation, matter transformed into idea. But are we not still interested in the actual business of finding colours and lines that will realize this transformation? I think that what the Expressionist artist is aiming at is the transmission, *without delay or interruption*, of the vibrations he has absorbed from the object. His colour choices in particular must correspond to the intention of demonstrating universal values, while he will still want not to lose the tone of personal emotional engagement.

This is, I would argue, an approximation of the general process. I admit that I cannot go much closer than this, since I have no direct experience of observing an Expressionist painter at work. What can be surmised, though, in the light of the generality of artists' statements about what they do, is that colour selection (as perhaps the most important item on the list of formal choices to be made) is not governed by thought but by spontaneous reflexes. And if the intellectual or analytical faculties are indeed in abeyance, as seems to be the case once an artist is engrossed in his work (if, to use Klee's phrase, he has reached that

happy state where 'colour and I are one'), then his relationship with his palette and his brush will become so intimate as to make those technical resources seem like extensions of his own physical nature. At which point the gesture of dipping the brush into a pot of green paint and applying it to the canvas is tantamount to an impulse moving out directly from within the creative sensibility, almost as if green paint were coming off the end of the hand as it dances through the air. (And what is Expressionist dance but a painting on air, that leaves no visible trace?)

In the final stage, I, as spectator, must stand before the painting and seek to adapt my affective being to the movements and vibrations which it embodies. As with my initial model of the Expressionist work, there seems to be an indexical relation implied here, the creative presence of the maker being bound in to the shapes of the made. Should I therefore be trying to relive these brush-strokes as the marks of bodily gestures? Should I try to embrace these colours and lines as an accessible equivalent to the artist's feelings?

I feel there is something lacking in my posture which is pulling me away from a direct apprehension of meaning. In many cases, such as the ones I have adduced, an isolated colour like red may well be the artist's wilful reference to a particularly acute emotion which, therefore, may be said to resonate on the canvas before me, and presently within me. But what happens when the situation gets more complex? Can I be sure of tuning in adequately to all the vibrations when I am faced with a dense piece of Expressionist art as it arrives at the extreme limit of abstraction? Let me take as my example Kandinsky's non-figurative canvas *Dreamy Improvisation* (1913). If I'm faced with that dancing square of crimson blobs, smears of cobalt blue and smudges of white and yellow, what good will it do me to mumble Kandinsky's dictum that 'the object reduced to its minimum must be recognized in its abstract form as the most potent efficacious Real'?[22] What if my senses can discern no familiar configuration, and no familiar pattern of colour?

How can I establish a stable context for my responses? Will not these inevitably be haphazard – shall I not risk tuning in to the 'wrong' vibrations?

Such anxiety may, arguably, be a small part of Kandinsky's intention. I should perhaps allow for a hint of estrangement or a whiff of dissonance as a refreshing preliminary response. But I want something more than a passing giddiness. I want to follow through on the task of imparting order to my responses. Let me try again. Given that there is no longer any identifiable object in the painting before me, I cannot channel my impressions into a ready-made format. These colours are not signals pointing to a fixed theme. Do they function autonomously, then, inside the aesthetic frame? No – for the Expressionist always insists that his work remains linked to the real, and never establishes a counter-reality. And I must admit that the picture I am looking at is, after all, an object itself within the same phenomenal world in which I breathe and walk. Now it dawns on me that these colours and shapes are here because a certain creative temperament had a specially heightened relationship with the very materials from which this picture is made. All at once, I begin to see things on two levels. There are natural objects before me (pigment, brushmarks, and so on). And these are *also* at the same time spiritual signs (extensions of a human sensibility which cannot be literally present). The beginnings of an answer to my problem now glimmer before me.

Things would, I realize ruefully, have been a lot easier if I had stuck with that indexical model on which I so long insisted. Alternatively, it might not have been too difficult to have switched over to a symbolic model, asking that the choice of colours, for instance, be set against a conventional code (blue = spirituality, etc.). But what I am now starting to recognize is that the most accurate shape for the Expressionist model at this extreme limit is a hybrid formed of the two. It is no longer enough to say that the marks on the canvas are 'indexical' in that they are the direct impress of the painter's gesture. Nor do I want to see them as simply

'symbolic', signs drawn from an extraneous code of intellectual equivalents. But *in between* the two models lies an area of revealing tension: here it is that the physical is aligned to the spiritual and the emotional, in such a way that the play of impulses situates itself as being more than just indexical and therefore as being 'liberated' from mimesis – yet not so 'liberated' from the world as to become pure semiosis, aesthetic play without concern for the real. The colours gleam in front of me to create an impression on my retina; yet what they signify cannot be reduced merely to the visible. The model I now need to work with is a conjunction of opposites: that of metaphor made concrete, the visible figure.

What I am suggesting is that in the creative development of an artist such as Kandinsky – and the same might be argued on a parallel track of a poet such as Trakl – iconic representation is superseded by a movement towards departicularization or universalization which *then* opens the way for a final stage in which the artist invests in the very materials of his medium – colour pigment (or, in the poet's case, colour adjectives!) – *as if* they were autonomous and non-referential. A picture or a poem may then take shape which owes its origin not to any external solicitation but to the pure urge to use brush or pen: the expressive impulse in its essential form. Then it is that the creative act achieves a mysterious transcendence. Then it is that the brush or pen, released from any willed intention, functions in its own capacity, and achieves fulfilment on its own terms.

'Abstract' art indeed? Is this not an art of autistic sterility, detached from life? Did not Kandinsky warn us about neckties and carpets? The answer must be that if the Expressionist is authentically in touch with his creative resources, he will, on the logic of the commitments I have tried to identify, arrive at last at a primal site within himself, at a central locus of confident fertility whence spring the truest impulses. And so, once I accept Kandinsky's maxim that 'abstract painting leaves behind the skin of nature, but not its laws',[23] it follows that even the least

overtly referential, the least thematically or structurally pre-ordained, the least orthodox and regulated motions of the artist's hand, will necessarily transpose vibrations of a natural kind. Kandinsky's *Dreamy Improvisation* now hovers before me, its colours aglow with meaning. They were born of a man's avowed concern for natural life. I myself feel that I am alive, intently looking. The shapes and colours I witness seem passionate, unmediated. I feel bound up with them in a transaction of expression and response at which words can only hint. Isn't this what Kandinsky meant by 'inner necessity'? A sensation of luminosity, of intimacy, encloses me. I accede at last to a radiant utopia defined by brush-strokes – it is here, it is now. The coloured surface has become a place of reciprocal presence. And when this wordless communion is complete, I shall return to an enhanced consciousness of my own being-in-the-world. Franz Marc again: 'Know now, my friends, what pictures mean: coming up to the surface in a different spot.'

CONCLUSION

In Dostoevsky's novel *The Idiot* (1868), there is a striking passage which describes the epileptic attacks to which the hero Prince Myshkin is prone. The actual fit is horrifying: the features of the face are distorted out of recognition, the body writhes in awful convulsions, and an inhuman scream bursts from the chest, sufficient to convey to others what Dostoevsky terms an 'absolute and unbearable horror, which has something mystical about it'.[1] And yet, for a moment or so just before the seizure, there occurs a wonderful flash of preternatural awareness, as if Myshkin's brain were catching fire and brilliant light were pouring into his mind and heart. In that heightened moment, time stands still, and the Prince's whole existence becomes a single sensation which he feels to the most intense degree. What does it matter if there is something abnormal about his condition? he asks himself, given that the negative experience of disease is so amply compensated for by the marvellous glimpse of a positive state, which, thanks to its survival in memory once the attack is over, remains as a sublime image in the mind, an inspiring feeling 'of completeness, proportion, reconciliation, and an ecstatic and prayerful fusion in the highest synthesis of life'.[2]

The passage provides a perfect summary of Expressionist themes and an allegory of what I see as a central Expressionist paradox, that extremes can combine in involuntary combinations which then take on meaning and necessity. The loathsome sense of utter wretchedness which is the subjectivity's response to undeserved pain or anxiety, is balanced by the premonition of access to sensations of

124

transcendent bliss in which the subjectivity feels itself to be intense and distinct, while at the same time fused with the dynamic pulse of universal existence. An implied tie between vulnerability and spiritual insight seems to run through Expressionist thought: extreme reaches of sensation and upsurges of metaphysical illumination assume a mysterious affinity, almost as if the Expressionist were capable of a magical act defying reason, whereby the positive is unthinkably drawn *out of* the negative. Kafka may have been thinking in such terms when he wrote that 'what in this world is called suffering, in another world, unchanged and only liberated from its opposite, is bliss'.[3] The suggestion I am making is that the darkness of anxiety and pain is, in some obscure way, a guarantor of that utopian optimism which then ensues, as if light were born of the deepest dark, hope out of horror.

Such a non-rational conjunction of ideas points a way to understanding the Expressionist mentality not in terms of clear-cut tenets which could be articulated as a mechanical credo, but as a swirling current of attitudes impelled by instinct and intuition. The Expressionist *does not think things through* – he feels, he guesses, he gambles. To the calculating mind, notions like 'suffering' and 'mystical feeling' are antithetical to reason, and, if they are concepts at all, are certainly not capable of reconciliation. Only at the level of unconscious process, within the sphere of the dream, as it were, can catastrophe be re-visualized as harmony, as synthesis. Whether we call this latter mode of mental behaviour 'unconscious', 'oneiric', 'primitive', 'mythical', 'mystical' or 'poetic' is a minor problem of semantics. What matters is that the Expressionist should be capable of such great enthusiasm for non-rational propositions and indeed thrive on the fact that they are at odds with orthodox thought. At the extremities of experience – in the conflictual epiphany where contraries fuse – his deep intimation of certainty is enough to convince him that he is indeed on the right track.

Of the various marks of Expressionism to which I have

pointed, that of using the negative mode as a stimulus to the positive is perhaps one of the most characteristic. As Rimbaud once discovered, dissonance for its own sake can be a curiously accurate pointer in the direction of a new harmony. Impetuous and often ill-argued, the case presented by the Expressionists themselves often starts out from an impulse of pure rebelliousness, only later to modulate into genuine argument. Did the Expressionists really so despise impressionism? There is evidence that, for many, impressionism was a first love. And yet, in the modernist debate, they found themselves taking an aggressive stand, lumping it along with naturalism as movements dedicated to superficial mimesis, and not to unveiling the deeper essence of the real. But had not the older Monet himself taken a step in just this direction? Tactically, perhaps, it was necessary to adopt the stance of rejection. Similarly, once their initial enthusiasm for cubism and orphism had passed, there are signs that the German artists distanced themselves once again, this time arguing that while those French-based movements were indeed as anti-mimetic as Expressionism, they were prone to a formalist tendency of an ultimately decorative and hence non-spiritual kind. The implication seems to be that the Expressionist instinct was to draw back from that which lacked any aura of *ethical* commitment, and above all from that which looked as though it were aimed to flatter the public retina rather than appeal to its spirit. It was the subsequent articulation of this instinctive preference for the spiritual, the mystical, the non-visible, which was to impart such a strong metaphysical flavour to the movement.

Spectacular recoil from established values is no doubt a feature of any new departure in the arts. An irrational antagonism to outside influences may be a necessary posture of survival for any avant-garde movement. But what is special about Expressionism is that its recoil from that which was other than itself was so manifold and so turbulent. To the list of aesthetic influences which it sought to combat may be added a yet longer one of moral and social

influences, underlining the point that Expressionism was not so much an artistic revolution as a movement of general rebellion on all fronts of the existential struggle. In terms of mental processes, it took an impulsive stand against the mechanical, positivist arguments of bourgeois civilization. Expressionism hated the ideology of money, calculation, mechanization. It hated imperialism and capitalism, it hated patriotism and the class system, it hated generals as it hated fathers. And so, when Hitler became dictator, Expressionism at once recognized the ultimate antithesis to itself, and saw no possibility of compromise.[4]

National Socialist ideology stands in such perfect contra-distinction to Expressionism that it is almost possible to define the latter purely as the inverted version of the former. Where Nazism extols the values of mass feeling, patriotism and authority, Expressionism gives priority to individual fantasy, a cosmopolitan outlook and personal initiative. Where Nazism extols the will to conformity and the observance of a rigid order, Expressionism emphasizes the impulse to be different and admires form born of spontaneity. Where Nazism means the chanting of slogans and the studied enactment of rituals of a military cast, Expressionism manifests itself in idiosyncratic and unprogrammed ways, with a strong emphasis on pleasure and emancipation.

So it was that when, speaking in 1937 at the opening of the Degenerate Art exhibition in Munich, Hitler castigated Expressionism as the product of defective vision, an infantile return to the Stone Age, a degradation of the pure Nazi spirit, he was at once signing the death-warrant of the movement and situating its lasting virtues. This plunge into nihilism, this overwhelming revenge of the 'Black Hand', prompts a strange flaring-up of the 'White Ray', a spurt of ecstasy stimulated by the presence of its contrary. And fortunately, despite the enormous dispersal and destruction of Expressionist works in the Nazi period, enough has survived for us to be able to see with unequivocal clarity the stages of that brave experiment in establishing a new vision of art and life.

Of course, it would be sentimental for me to overlook the failings of Expressionism. As a movement it lost momentum through its lack of a vocal centre, from which it might have derived a sense of cohesion and collective definition. In its style of transmission, it often transgressed even its own immoderate limits by inflating gesture into unbecoming exaggeration, traducing primal sincerity and offering super-charged sham. Its poems were sometimes too staccato or strained to seem more than noisy provocation; its films eventually lapsed out of the mode of psychological suspense and into that of surface thrills. Sometimes its plays were too jerky to make coherent sense, or its paintings too frantic to seem at all authentic. The direct expression of raw feeling can conduce to indigestibility; extravagant gestures whose sole purpose is to shock create a numb distaste which can only be stirred by further shocks in an ultimately sensationalist and sterile fashion. Morbid violence and the flourishing of bombastic watchwords, such as that of the 'New Man', contribute to an inflationary spiral with a desperate, kitsch uniformity as the result.

But such failings may seem excusable in a movement so widespread, so ambitious, so marvellously *enthusiastic*. Which of the modern movements in the arts has not given rise to caricature and exaggeration, in the work of its disciples, if not in that of its masters? What matters is that a central corpus of major works was produced which is still capable, a half-century on, of imparting values to us.

It seems to me that what Expressionism was really after was a reform of consciousness on the widest scale. It felt itself to be in touch with the true meaning of what it is to be alive; it supposed that the individual is entitled to be in the world, and to seek out the essentials of a full existence. Working from a concern with artistic expression, it broadened its vision to embrace the whole of life, and in this sense applied aesthetic axioms to the problems of daily existence, demanding a qualitative approach which respects the individual and his right freely to express preferences and feelings which others might share. It defined a

principle of transparent unison in human relations, not in order that private lives should be wantonly exposed, but so that true desires could at last be defined and released. It sought to transfigure consciousness, to create a fresh context of understanding in which the human condition could at last be examined as it deserves – in the light of passion. In its ethical thrust, its insistent claim to show what life *could* be like, Expressionism aimed far beyond what is practicable, and so ended up pointing to a horizon of possibilities still beyond our reach. In this it was truly utopian. Yet there is a kind of pointing which is empty because it carries no conviction, and is merely a gesturing in the void, a lifeless reflex. And then there is that gesturing which embodies what Ernst Bloch calls 'the Principle of Hope'. It is this sort of gesture, at once empty and full of potency, this appeal to a kind of resonant absence, which is the sign that Expressionism makes, as an exhortation to our present age. No more need be said than that individual feeling and the instinct to press beyond appearances remain values worth fighting for.

NOTES

FOREWORD

1. As is sometimes the case with critical terms applied to avant-garde movements, the way the term 'Expressionist' acquired its present meaning is an obscure and confused story. One theory dates its first usage to 1901, when an otherwise forgotten painter called Julien-Auguste Hervé exhibited eight paintings at the Salon des Indépendants in Paris under the generic title *Expressionismes*. Since these were works in a retrograde naturalistic style, we may infer that the artist simply intended to register his disapproval of impressionism. There is an anecdote to suggest that the German dealer Paul Cassirer launched the term some years later when he declared a canvas by Max Pechstein to be 'Expressionist' as opposed to 'Impressionist', implying that the latter style was now outdated. In 1909 appeared the German version of Henri Matisse's influential *Notes of a Painter* (*Notes d'un peintre*), asserting his allegiance to a subjective approach to creativity and placing 'expression' at the forefront of the artistic project. Perhaps the first decisive use of the term 'Expressionism' came in 1911, when the Secession Exhibition in Berlin devoted a large section to Paris-based cubists and fauvists including Braque, Derain, Dufy, Friesz, Picasso and Vlaminck, grouping them in the catalogue as 'Expressionists'. However, none of these artists was actually German, and at an exhibition in Düsseldorf in the same year, and another at the Sturm Gallery in Berlin a year later, the term was still being used to classify a similar set of non-German painters. While the term was gaining currency, its meaning remained vague, as witness its application, at the 1912 Sonderbund Exhibition in Cologne, to such unlikely names as Cézanne, Signac and Bonnard, who

were classed as 'Expressionists' along with painters who would now seem to be more sensible choices: van Gogh, Munch, Vlaminck, Kirchner, Heckel, Kokoschka, etc. More time had to pass before the term was finally narrowed to a focus on German art in critical monographs like Paul Fechter's *Der Expressionismus* (1914) and Hermann Bahr's *Expressionismus* (1916); its literary application ensued with Kurt Pinthus's 1919 anthology *Twilight of Mankind* (*Menschheitsdämmerung*). The specifically Germanic accent was thus struck only at a late stage in the evolution of that German art which the term now customarily designates.

It is interesting to see the tentative way in which what now seems an indispensable term became accepted. A non-German coinage seemingly imported from the avant-garde capital of Paris, *Expressionismus* appears to have had the character of a provocatory label denoting all things foreign, exotic and daring, while at the same time, in its form, signalling that impressionism had been superseded. The irony is that its application is more a concern of art historians than of artists. Kirchner, leader of the Bridge, rejected it as a phony catchword, while Kandinsky and Marc simply never used the word. It remains, ultimately, a critical convenience; its efficacy is proportionate to the clarity with which its scope is defined.

2. Let me indicate my major distinctions. I have ignored without malice a few non-vehement artists on the fringe of Expressionism: Paula Modersohn-Becker, Christian Rohlfs, Heinrich Campendonk. I have excluded consideration of the *Neue Sachlichkeit* ('New Matter-of-Factness') school (Max Beckmann, George Grosz, Otto Dix), which, though indebted to the Expressionist example, pursued a different, more down-to-earth line. I do not refer to Bertolt Brecht or the Berlin Dadaists, whom I take to be interesting enemies of Expressionism. I *do* mention artists such as Paul Klee, Käthe Kollwitz and Alfred Kubin, who are often given marginal status, yet whose contributions are, in my view, very much in tune with central Expressionist ambitions. Of the film-makers, I include mention of Fritz Lang (at least up until 1933), but have reservations about Georg Pabst. I treat the Bauhaus as an Expressionist phenomenon, even if it did not remain so throughout its existence. Of the writers, I have felt

no qualm about treating Georg Heym, Georg Trakl and Franz Kafka as Expressionists. How else might they be treated? Why, as outstanding writers in their own right! But then (the argument might run) *any* outstanding writer with a distinctive style will automatically disqualify himself from discussion. Deviations and idiosyncrasies there are aplenty in the Expressionist movement: but its very nature was that it should encourage differences, if not 'marginality'. Perhaps the best way to decide whether it makes sense to take a given individual as an example which illuminates Expressionism, is to ask the question: does Expressionism illuminate him?

I EXPRESSION AND EXPRESSIONISM

1. There remains the special case of the man weeping all on his own. Is his unequivocal outburst of grief to be seen as intentional communication? Arguably yes, in that he may in a sense be crying so as to express grief *to himself*. At least it should be acknowledged that a person whose private tears are witnessed by an intruder will automatically assume that the true state of his emotions has been made *visible* rather than kept hidden.

2. Quoted in Graetz, H.R. *The Symbolic Language of Vincent van Gogh* (London: Thames and Hudson, 1963), p.13.

3. Quoted in Blackham, H.J. *Six Existentialist Thinkers* (London: Routledge & Kegan Paul, 1961), p.24.

4. In Hess, W. (ed.) *Dokumente zum Verständnis der modernen Malerei* (Hamburg: Rowohlt, 1956), p.46.

5. Quoted in Dewey, J. *Art as Experience* (New York: Capricorn Books, 1958), p.72.

6. Quoted in Dube, W.-D. *The Expressionists* (London: Thames and Hudson, 1972), p.112.

7. Quoted in Viviani, A. *Dramaturgische Elemente des expressionistischen Dramas* (Berlin: Bouvier, 1970), p.49.

8. In Lankheit, K. (ed.) *The Blaue Reiter Almanac* (London: Thames and Hudson, 1974), p.85.

9. Quoted in *Käthe Kollwitz 1867–1945. The Graphic Works* (Cambridge: Kettle's Yard, 1981), p.7.

10. Quoted in Miesel, V.H. (ed.) *Voices of German Expressionism* (Englewood Cliffs, N.J.: Prentice-Hall, 1970), p.10.

11. Quoted in Martin, J. *Introduction to the Dance* (New York: Dance Horizons, 1965), p.238.

12. The activity dubbed 'Action Painting' in 1950s New York may be seen as the logical extension of this performance-oriented model, whereby the picture tends to take its reference and value from the notion of the artist's presence, gesturally imparted into the pigment. The prime example is Jackson Pollock, who used to lay his canvas on the floor and then walk over it carrying dribbling cans of paint, literally establishing his physical presence on the picture surface. The traditional gap between the artist's physical gesture or posture and the finished work is further narrowed in the recent development of 'Performance Art'. An example of this is the work of Arnulf Rainer, who explores the expressive resources of incoherent stammerings, facial grimaces and the like. Though he does produce a photographic record of his performances, it is still arguable that the expressive locus of Rainer's art remains his own body.

13. I am borrowing Peirce's celebrated trichotomy as a convenient way to highlight aspects of the expressive sign, seen in terms of its relation to its referent. In accentuating the 'indexical' dynamism of the sign in Expressionism, I am mindful of Peirce's definition of the index as 'a sign which refers to the Object that it denotes by virtue of being really affected by that Object', and of his observation that 'it takes hold of our eyes, as it were, and forcibly directs them to a particular object' (Peirce, C.S., *Collected Papers* [Cambridge, Mass. Belknap Press, 1960] vol. II, p.143; vol. III, p.211). The convolutions of Peirce's semiotic system may be pursued in detail in his *Speculative Grammar* (in *Collected Papers*, vol. II).

14. Quoted in Thorlby, A. *Kafka* (London: Heinemann, 1972), p.18.

15. In Miesel, *op. cit.*, p.48.

16. The fact that photography situates itself readily within an iconic mode – a snapshot of the Eiffel Tower will unequivocally resemble the Eiffel Tower – may be part of the reason why German Expressionism failed to produce any photographers. One exception might be Wols, who took still-life photos in which supercharged emotions in an anguished register can be clearly discerned. To designate his images as simply 'indexical' would be problematic, however. The exis-

133

tential connection of object and emulsified film-strip may be an indexical one (though to argue in this way might be seen as a distortion of Peirce's intentions), but it is also true that Wols's flayed rabbit on a pavement is not only iconic (clearly identifiable as a rabbit!) but also *symbolic* (it evokes associations of torture and death, hence establishing itself as a nexus of cultural meanings).

17. Stramm, A. *Dein Lächeln weint* (Wiesbaden: Limes, 1956), p.75.

II THE EXPRESSIONIST PROJECT

1. Quoted in Hibberd, J. *Kafka* (London: Studio Vista, 1975), p.117.
2. In Pinthus, K. (ed.) *Menschheitsdämmerung* (Hamburg: Rowohlt, 1959), p.217.
3. Trakl, G. *Das dichterische Werk* (Munich: Deutscher Taschenbuch Verlag, 1972), p.32.
4. Janouch, G. *Gespräche mit Kafka* (Frankfurt a. M.: Fischer, 1968), p.248.
5. Strindberg, A. *The Father & A Dream Play* (Northbrook, Ill.: A.H.M., 1964), p.62.
6. Quoted in Dube, W.-D. *The Expressionists* (London: Thames and Hudson, 1972), p.96.
7. Quoted in Hamburger, M. *Reason and Energy* (London: Routledge & Kegan Paul, 1957), p.287.
8. Of the Expressionist attitude to women, it can be generally contended that the reactionary views of a Schopenhauer (woman as man's mindless foe) or a Strindberg (sexual love as inferno) are more dominant than the emancipatory views of a Novalis (woman as embodiment of intuitive wisdom) or an Ibsen (woman splendidly asserting her identity). There are a good many examples of Expressionist painters who depict women in a violent or degrading manner (Munch, Kokoschka, Schiele, Kirchner, Permeke, etc.; especially virulent are the *Neue Sachlichkeit* painters Beckmann and Dix). That caricature and distortion are 'also' characteristics of the formal revolution in painting does not excuse blatant sexism, as admirers of Picasso's expressionistic women might note! There are, on the other hand, moving examples of the tender treatment of women figures (Mueller, Macke, Jawlensky).

Feminists may want to pursue the question why those few Expressionist painters and poets who *are* female (Paula Modersohn-Becker, Gabriele Münter, Else Lasker-Schüler, Claire Goll) tend, more often than not, to be omitted from studies of the movement as being (presumably?) overly tentative or lacking in expressive momentum. Käthe Kollwitz alone emerges with anything like the reputation of her male counterparts. Only in the performing arts – with, for instance, the dancer Mary Wigman, the stage actresses Gerda Müller, Gertrud Eysoldt and Agnes Straub, and the film actress Asta Nielsen – is the balance somewhat redressed.

9. So prevalent is the 'death wish' as a theme that it comes as a surprise to find that, in practice, there are very few actual suicides among the major Expressionists. The important names would be van Gogh, Trakl, Kirchner, Toller, Carl Einstein and Alfred Wolfenstein. But practically all of these suicides could be interpreted as a response to specific external pressures, rather than to an intention long nurtured. To speak of a 'cult' of suicide in Expressionist art is thus to speak of a temptation or a virtuality (some might say an affectation) rather than an existential choice. Indeed, Expressionist violence at large may well be a reflection of aesthetic ambitions: non-transitive signals, so to speak, as distinct from transitive or literal ones. It is a complex psychological question, beyond the compass of this essay, as to whether impulses which achieve expression in works of art thereby forfeit their literal potency, no longer needing to carry across into the field of material action. My description of Expressionist aesthetics simply points to the unspoken assumption that impulses are not blunted but, rather, enhanced by expression.

10. Heym, G. *Gedichte und Prosa* (Frankfurt a.M.: Fischer, 1962), p.35.

11. In Hess, W. (ed.) *Dokumente zum Verständnis der modernen Malerei* (Hamburg: Rowohlt, 1956), p.89.

12. In Pinthus, *op.cit.*, p.39.

13. *Ibid.*, p.47.

14. *Ibid.*, pp.79–80.

15. *Ibid.*, p.235.

16. *Ibid.*, p.216.

17. Quoted by Sheppard, R. in Bradbury, M. & McFarlane, J. (eds.) *Modernism* (Harmondsworth: Penguin, 1976), p.277.

18. Quoted in Martin, J. *Introduction to the Dance* (New York: Dance Horizons, 1965), p.238.

19. It may be noted that the Communist Youth in Germany was every bit as enthusiastic about the code of fitness as was the Hitler Youth. It follows that for a specific political ideology to lay claim to a given social practice is not to establish a uniform meaning for such practice. Any facile assimilation of Expressionist enthusiasm for the body to Nazi ideals should therefore be rejected: the former's commitment to individual spontaneity is far removed from the latter's ethic of collective fitness, evidenced in the ritualistic demonstrations of massed gymnasts recorded in propaganda films.

20. In Pinthus, *op.cit.*, p.279.

21. *Ibid.*, p.367.

22. Kaiser, G. *Werke* (Frankfurt a.M.: Propyläen, 1971), vol. IV, p.574.

23. In Pinthus, *op.cit.*, pp.224, 253, 196.

24. Ironically, the Expressionist ideal of transparency survives in a debased form, inasmuch as the model of the glass-clad skyscraper which Mies van der Rohe brought from the Bauhaus to America has evolved into the present-day stereotype of the impersonal office block. Thus it is that an idealistic principle becomes perverted: far from being an emblem of the Expressionist vision, today's glass tower is the sign of commerce and of an anti-Expressionist disdain for individuality.

25. Quoted in Lane, B.M. *Architecture and Politics in Germany, 1918–1945* (Cambridge, Mass.: Harvard U.P., 1968), p.46.

26. *Ibid.*, p.48.

27. Quoted in Rothe, W. (ed.) *Expressionismus als Literatur* (Berne: Francke, 1969), p.474.

III THE SPIRITUAL IMPULSE

1. Quoted in Read, H. *A Concise History of Modern Painting* (London: Thames and Hudson, 1974), p.244.

2. 'Abend in Lans', in Trakl, G. *Das dichterische Werk* (Munich: Deutscher Taschenbuch Verlag, 1972), p.54

3. Kafka, F. *The Trial (etc.)* (London: Secker & Warburg, 1976), p.764.

Notes

4. Quoted in Dube, W.-D. *The Expressionists* (London: Thames and Hudson, 1972) p.126.

5. *Ibid.*, p.173.

6. In Miesel, V.H. *Voices of German Expressionism* (Englewood Cliffs, N.J.: Prentice-Hall, 1970), p.39.

7. Quoted in Eisner, L.H., *The Haunted Screen* (London: Secker & Warburg, 1969), p.127.

8. In Lankheit, K. (ed.) *The Blaue Reiter Almanac* (London: Thames and Hudson, 1974) p.250.

9. One of the paradoxes in the study of the influences of tribal art on European artists of this century is that whereas masks created by men from non-European regions may look strange and powerful, it does not follow that their authors worked in a free and inspirational manner. The evidence is that, more often than not, a given carving from black Africa or New Guinea will be an exercise in the replication of highly systematized models – stereotypes, in other words. Thus, when a European artist like Kirchner or Nolde feels himself to be in the presence of something he calls the 'Primitive', he may well be succumbing to a mythical affect. One might want to query the validity of a theory of primal purity which may turn out to be conditioned by cultural relativism, plus an irrational longing for the exotic. Did Gauguin really improve as a painter for having journeyed to Tahiti? Would Klee's work have faltered had he not been stimulated by children's drawings? I suggest that there is less point in asking whether an artist was misguided in his ideological assumptions than in establishing whether he went on to produce works that have the capacity to compel our attention. Within the Expressionist model, it can be argued that a work of art may still emerge as genuinely *felt*, even if its maker were labouring under some intellectual misapprehension.

10. In Miesel, *op.cit.*, p.37.

11. Quoted in Martin, J. *Introduction to the Dance* (New York: New Horizons, 1965), p.230.

12. In Miesel, *op.cit.*, pp.180–1.

13. Stramm, A. *Dein Lächeln weint* (Wiesbaden: Limes, 1956), pp.49–50.

14. In Pinthus, K. (ed.) *Menschheitsdämmerung* (Hamburg: Rowohlt, 1959), p.163.

Notes

15. E. Stadler, *Gedichte und Prosa* (Frankfurt a.M.: Fischer, 1964), p.98.
16. *Ibid.*, p.72.
17. In Miesel, *op.cit.*, p.183.
18. In Pinthus, *op.cit.*, p.201.
19. Quoted in Dube, *op.cit.*, p.115.
20. In Hess, W. (ed.) *Dokumente zum Verständnis der modernen Malerei* (Hamburg: Rowohlt, 1956), p.48.
21. *Ibid.*, p.79.
22. Quoted in Haftmann, W. *Painting in the Twentieth Century* (London: Lund Humphries, 1965), vol. II, p.126.
23. Quoted in Lankheit, K. *Franz Marc* (Berlin: Lemmer, 1950).
24. In Miesel, *op.cit.*, p.93.
25. In Hess, *op.cit.*, p.87.
26. An influential ambiguity dating back to romanticism is that nature can denote either (i) the non-self, or that which is other than the single ego, or (ii) the world which lacks the imprint of man, i.e., the non-urban environment, the countryside. While here and there Kandinsky will equate mystic feeling with the trivia of urban existence, extracting his epiphany from 'a cigarette butt lying in an ashtray, a patient white trouser button looking up from a puddle in the street', it is the usual case that Expressionist mystical feeling addresses itself to the unconstrained spaces of nature in the second sense, attaining its apotheosis in images of mountains, lakes and forests. (Kirchner's big-city pictures are an obvious exception, but are counterbalanced by his late mountain-scapes.) Allegiance to the romantic equation between open landscape and spiritual uplift (most forcefully dramatized in the spectral mountain scenes of Caspar David Friedrich) sets Expressionism apart from the *Neue Sachlichkeit* trend which emerged towards 1925. Painters like Grosz and Dix were the very obverse of starry-eyed mystics, and their acerbic perceptions are unthinkable outside the crowded, noisy context of Berlin.
27. Quoted in Dube, *op.cit.*, p.176.
28. In Hess, *op.cit.*, p.45.
29. Though I would feel it misleading to include the anthroposophist Rudolf Steiner within my definition of Expressionism, it is worth noting that Steiner's whole intellectual system derives from Goethian patterns of thought and that his major excursion into practical architecture, the organically con-

ceived Goethianum building in Dornach, Switzerland (1914), is frequently quoted as a para-Expressionist work.

30. I recognize that Arp's formal affiliation was to dadaism, and subsequently to surrealism (in a looser sense). All the same, it should not be forgotten that Arp exhibited alongside the Expressionists in Berlin in 1912–13, and knew Klee and Kandinsky personally. Arp's lifelong commitment to Chance as a creative agency is not at all incompatible with romantic notions of natural teleology, while the neo-romantic strain in his sensibility is amply confirmed in his poetry, where, alongside the dada nonsense, there flourishes a rich elemental imagery of stones, plants and water.

31. Quoted in Dube, *op.cit.*, pp.153–4.

32. Other contributory influences, which I lack space to examine, include Madame Blavatsky's system of Theosophy, which Kandinsky for one took most seriously, and the philosopher Henri Bergson's insistence on seeing intuition as the superior faculty in man. Bergson it was who saluted art as the intuitive medium *par excellence* which would 'brush aside the utilitarian symbols, the conventional and socially accepted generalities, in short everything that veils reality from us, in order to bring us face to face with reality itself'.

33. In Hess, *op.cit.*, p.47.

34. *Ibid.*, pp.79–80.

35. Quoted in Thoene, P. *Modern German Art* (Harmondsworth: Penguin, 1938), p.66.

36. Quoted in Corlett, A. *Art of the Invisible* (Jarrow: Bede Gallery, 1977), p.76.

37. Kandinsky, W. *Ueber das Geistige in der Kunst* (Munich: Piper, 1912), p.119.

38. I have somewhat exaggerated Worringer's commitment to a mythology of Nordic unease, the Germanic artist seen as a wild and unsettled individual cut off from reality and unable to focus on immediate problems. This is to reflect a popular current of thought sponsored by Worringer's work. In fact, Worringer did proceed to hypothesize a future synthesis in which the young artists of the abstract school would group their talents in the production of monumental and elemental forms, transmitting to the community at large a vision of a higher unity. The romantic ideal of organic cohesion is projected by Worringer from the art-work on to the commun-

ity: in his vision – not dissimilar to that of a Taut, after all – there will emerge, thanks to the regenerative inspiration of art, a social order wherein individualistic despair can be transcended. Ultimately, however, Worringer felt that Expressionist art was unlikely to take the lead in this work of renewal, and settled his hopes on modern science as the more likely agent of progress.

39. In Hess, *op.cit.*, p.78.

IV STYLE AND RESPONSE

1. In Pinthus, K. (ed.) *Menschheitsdämmerung* (Hamburg: Rowohlt, 1959), p.253.
2. *Ibid.*, pp. 164, 86.
3. *Ibid.*, p.289.
4. In Miesel, V.H. (ed.) *Voices of German Expressionism* (Englewood Cliffs, N.J.: Prentice-Hall, 1970), pp. 113–14.
5. Heym, G. *Gedichte und Prosa* (Frankfurt a.M.: Fischer, 1962), p.66.
6. Quoted in Dube, W.-D. *The Expressionists* (London: Thames and Hudson, 1972), p.118.
7. Quoted in Hamann R. & Hermand, J. *Expressionismus* (Berlin: Akademie-Verlag, 1975), p.14.
8. Stramm, A. *Dein Lächeln weint* (Wiesbaden: Limes, 1956), p. 80.
9. *Ibid.*, pp.84–5.
10. Quoted by Brinkmann, R. in Rehder, H. (ed.) *Literary Symbolism* (Austin, Texas: Texas U.P., 1965), p.131.
11. A parallel experiment in 'primal sounds' was carried out in Zürich by the German poet Hugo Ball in 1916. Ball's earnestness about his work distances it from the gay abandon of the dada poetry produced by associates like Tristan Tzara, and reflects Ball's temperamental affinity with the more introspective, spiritual wing of German Expressionism.
12. Heym, *op.cit.*, p.18; and Lasker-Schüler, E. *Helles Schlafen – dunkles Wachen* (Munich: Deutscher Taschenbuch Verlag, 1962), p.62.
13. Respectively quoted in Pinthus, *op.cit.*, pp.59, 63; and Schneider, K.L. *Zerbrochene Formen* (Hamburg: Hoffmann & Campe, 1967), p.41.

Notes

14. Trakl, G. *Das dichterische Werk* (Munich: Deutscher Taschenbuch Verlag, 1972), p.63.
15. In Miesel, *op.cit.*, p.36.
16. The term 'Blue Rider' was coined by Marc and Kandinsky one evening in 1911, allegedly without forethought. Kandinsky explains: 'Both of us loved blue, Marc horses and I horsemen. So the name came by itself.' Yet the resonances of the formula are, I would argue, so strong as to be more than casual, and lend poetic force to the group's public name. The phrase might, in the German cultural context, be expected to trigger a ready association with the 'blue flower' of romantic yearning, a key symbol for Novalis. Further associations derive from natural and cultural codes. Blue is rarely found in nature except as the colour of the sky, and hence carries connotations of the spiritual, the other-worldly. It is the colour of the pure, the virginal (cf. the use of blue for the Virgin's mantle in traditional Christian painting). Kandinsky refers to blue in *On the Spiritual in Art* as 'the typical heavenly colour'. As for the horseman, I would suggest this to be an echo of, on the one hand, the 'Cossack' motif in early Kandinsky (several early pictures depict groups of wild horsemen, and one at least of these is plainly entitled *The Rider*), and, on the other, a Biblical reference to the Horsemen of the Apocalypse, who are the bearers of devastation and death. Seen in the light of such associations, the 'Blue Rider' formula may look to be a contradiction in terms, spiritual renewal being pitted against spiritual despair. But let us listen to a phrase of Marc's from the text of a prospectus for the 1912 Almanac: 'We stand before the new pictures as in a dream and we hear the apocalyptic horsemen in the air.' The tonality here surely imposes positive resonances of regeneration over any destructive ones: the word 'apocalypse' can also mean revelation and the vision of the new. As a watchword for the movement, the 'Blue Rider' tag may thus be understood as embodying an aesthetic and ethical programme aimed at overturning materialism and reinstating spiritual harmony.
17. Quoted in Dube, *op.cit.*, p.128.
18. I can anticipate the contradictions that would arise if I insisted on an unswerving equivalence such as 'blue = pure spirituality'. A canvas such as Kirchner's *Recumbent Blue Nude*

141

with Straw Hat (c. 1909) takes the spectator quite assertively into a carnal register.

19. Quoted in Dube, *op.cit.*, p.115.
20. *Ibid.*, p.150.
21. Quoted in Thoene, P. *Modern German Art* (Harmondsworth: Penguin, 1938), p.68.
22. In Hess, W. (ed.) *Dokumente zum Verständnis der modernen Malerei*: (Hamburg: Rowohlt, 1956), p.88.
23. *Ibid.*, p.87.

CONCLUSION

1. Dostoevsky, F. *The Idiot* (Harmondsworth: Penguin, 1955), p.268.
2. *Ibid.*, p.258.
3. Quoted in Hibberd, J. *Kafka* (London: Studio Vista, 1975), p.95.
4. The full story of the Nazi repression is long and not without several points of controversy. None the less, I would make the emphatic point that of all the dozens of artists and writers who contributed to Expressionism, the merest handful made any sort of appeasing or welcoming gesture to Nazism. The list of those who were vilified, hounded out of their jobs, prevented from publishing or exhibiting, and eventually hustled into exile or, in certain cases, brought directly or indirectly to their deaths, represents an impressive and consistent record.

SELECT BIBLIOGRAPHY

This is a selection of general works about Expressionism; it makes no attempt to cover the immense range of studies of individual figures.

Allen, R. *German Expressionist Poetry* (Boston: Twayne, 1979)
 Literary Life in German Expressionism and the Berlin Circles (Göppingen: Kümmerle, 1974)
Arnold, A. *Die Literatur des Expressionismus.*
 Sprachliche und thematische Quellen (Stuttgart: Kohlhammer, 1966)
Bablet, D. & Jacquot, J. (eds) *L'Expressionisme dans le Théâtre européen* (Paris: Editions du C.N.R.S., 1971)
Benton, T. with Benton, C. & Sharp, D. *Expressionism* (Milton Keynes: Open University, 1975)
Brinkmann, R. *Expressionismus. Internationale Forschung zu einem internationalen Phänomen* (Stuttgart: J.B. Metzler, 1980)
Bronner, S. & Kellner, D. (eds) *Passion and Rebellion: the Expressionist Heritage* (London: Croom Helm, 1981)
Buchheim, L.-G. *Der Blaue Reiter und die neue Künstlervereinigung München* (Feldafing: Buchheim, 1959)
Denkler, H. *Drama des Expressionismus* (Munich: Fink, 1967)
Dube, W.-D. *The Expressionists* (London: Thames and Hudson, 1972)
Eisner, L. H. *The Haunted Screen* (London: Secker & Warburg, 1969)
Furness, R.S. *Expressionism* (London: Methuen, 1973)
Gerhardus, M. & D. *Expressionismus. Vom bildnerischen Engagement zur Kunstwende* (Freiburg: Herder, 1976)
Goldwater, R. *Primitivism in Modern Art* (New York: Vintage Books, 1967)

Haftmann, W. *Painting in the Twentieth Century* (London: Lund Humphries, 1965)

Hamann, R. & Hermand, J. *Expressionismus* (Berlin: Akademie-Verlag, 1975)

Hamburger, M. *Reason and Energy* (London: Routledge & Kegan Paul, 1957)

Hospers, J. (ed.) *Artistic Expression* (New York: Appleton-Century-Crofts, 1971)

Kandinsky, V. *Complete Writings on Art* ed. Lindsay, K.C. & Vergo, P., 2 vols. (London: Faber & Faber, 1982)

Knapp, G.P. *Die Literatur des deutschen Expressionismus* (Munich: Beck, 1979)

Kozloff, M. 'The Dilemma of Expressionism' in *Renderings* (London: Studio Vista, 1970)

Kurtz, R. *Expressionismus und Film* (Zürich: Rohr, 1965)

Lane, B.M. *Architecture and Politics in Germany, 1918–1945* (Cambridge, Mass.: Harvard U.P., 1968)

Lankheit, K. (ed.) *The Blaue Reiter Almanac* (London: Thames and Hudson, 1974)

Martin, J. *Introduction to the Dance* (New York: Dance Horizons, 1965)

Miesel, V.H. (ed.) *Voices of German Expressionism* (Englewood Cliffs, N.J.: Prentice-Hall, 1970)

Muller, J.-E. *A Dictionary of Expressionism* (London: Eyre Methuen, 1973)

Myers, B.S. *The German Expressionists* (New York: Praeger, 1957)

Paulsen, W. *Deutsche Literatur des Expressionismus* (Berne: Herbert Lang, 1983)

Pehnt, W. *Expressionist Architecture* (London: Thames and Hudson, 1973)

Perkins, G. *Contemporary Theory of Expressionism* (Berne: Herbert Lang, 1974)

Pinthus, K. (ed.) *Menschheitsdämmerung. Ein Dokument des Expressionismus* (Hamburg: Rowohlt, 1959)

Raabe, P. *The Era of German Expressionism* (Woodstock, N. Y.: Overlook, 1974)

Ragon, M. *L'Expressionisme* (Lausanne: Rencontre, 1966)

Richard, L. (ed.), *L'Expressionisme allemand, Obliques* Nos 6–7 (Paris, 1976)

Ritchie, J.M. *German Expressionist Drama* (Boston: Twayne, 1976)

Rosen, C. *Schoenberg* (London: Fontana, 1976)

Rosenblum, R. *Modern Painting and the Northern Romantic Tradition: Friedrich to Rothko* (London: Thames and Hudson, 1975)

Rothe, W. (ed.), *Expressionismus als Literatur* (Berne: Francke, 1969)

Schneider, K.L. *Zerbrochene Formen. Wort und Bild im Expressionismus* (Hamburg: Hoffmann & Campe, 1967)

Selz, P. *German Expressionist Painting* (Berkeley: California U.P., 1957)

Sheppard, R. 'German Expressionism' in *Modernism 1890–1930*, Bradbury, M. & McFarlane, J. (eds.) (Harmondsworth: Penguin, 1976)

Sokel, W.H. *The Writer in Extremis* (Stanford: Stanford U.P., 1959)

Thoene, P. *Modern German Art* (Harmondsworth: Penguin, 1938)

Vietta, S. & Kemper, H.-G. *Expressionismus* (Munich: Fink, 1975)

Viviani, A. *Dramaturgische Elemente des expressionistischen Dramas* (Berlin: Bouvier, 1970)

Vogt, P. *The Blue Rider* (Woodbury: Barron's, 1980)

Weisstein, U. (ed.) *Expressionism as an International Literary Phenomenon* (Paris/Budapest: Didier & Akademiai Kiado, 1973)

Whitford, F. *Expressionism* (London: Hamlyn, 1970)

Willett, J. *Expressionism* (London: Weidenfeld & Nicolson, 1970)

Worringer, W. *Abstraction and Empathy. A Contribution to the Psychology of Style* (London: Routledge & Kegan Paul, 1953)

INDEX

Index

Index

Index